In Person

MY COUNTRY

MY COUNTRY

50 MUSICIANS ON GOD, AMERICA & THE SONGS THEY LOVE

MELANIE DUNEA

BOOK DESIGN BY GIOVANNI CARRIERI RUSSO NO11, INC.

COVER DESIGN & CHAPTER TYPOGRAPHY © HATCH SHOW PRINT® NASHVILLE, TN. JENNIFER BRONSTEIN, DESIGNER.

RODALE®

FOR NIGEL

MUSICIANS

Kenny Chesney

Miranda Lambert

Jim Lauderdale

Charley Pride

Carrie Underwood

Reba McEntire

Heidi Newfield

Ray Benson

Julianne Hough

David Allan Coe

Trace Adkins

Martina McBride

John Rich

Barbara Mandrell

Little Jimmy Dickens

Rosanne Cash

Brad Paisley

JD Souther

Sugarland

The Oak Ridge Boys

Wynonna Judd

Bill Anderson

Jake Owen

Kenny Rogers

Trisha Yearwood

Glen Campbell

Taylor Swift

Darius Rucker

Patty Loveless

Rodney Atkins

Joe Nichols

Mel Tillis

Josh Turner

Crystal Gayle

Little Big Town

George Jones

Clint Black

Roy Clark

Gretchen Wilson

Randy Travis

Blake Shelton

Marty Stuart

Vince Gill

Jimmy Wayne

Shelby Lynne

Brooks & Dunn

Jack Ingram

Lee Ann Womack

Dwight Yoakam

Rodney Crowell

WHY COUNTRY?

That is a very good question, considering I am a full-blown Yankee who grew up in downtown Chicago to the dulcet sounds of Madonna and Michael Jackson. Though I spent one month a summer in Des Moines, Iowa, nary a country tune graced my ears.

Okay, maybe "Islands in the Stream," by Dolly Parton and Kenny Rogers.

My Country all started back in September 2003, when my phone rang and Kenny Chesney was on the other end. We had just done a magazine shoot. Two thoughts ran through my mind. First I thought, what if he didn't like the shoot, and second, where did he get my cell phone number?

Hel-lo, Melanie, he's Kenny Chesney; he probably has the president's cell number. It turned out he was calling to tell me, ask me, or rather insist that I come and shoot his new album cover on the island of St. John in two weeks' time. It might sound like paradise, but sun, sand, and surf do not an easy photo shoot make.

We ended the shoot the best of friends with only a minor glitch. (Both strong-minded, Kenny and I disagreed over where the cowboy hat would sit on his head.) Most important, the shoot was my introduction to world of country music. I could get used to this, I remember thinking; nice, grounded people with real vision.

Fast forward to 2008. I had just finished a book about chefs and their last meals on earth. After throwing myself headfirst, or shall I say mouth first, into the chef project, I felt lost. I'd so enjoyed the process of making *My Last Supper*, I wanted to delve into another all-consuming project, but I struggled to think of a new idea. I had only one guiding principle: It had to be a group of people that I really knew nothing about. I knew how time-intensive a book could be, and I wanted to explore a completely new and interesting world.

Meanwhile, in my job as a photographer, I started to get more and more

commissions to shoot country musicians for magazines and album covers. As I traveled around shooting them, I saw this was a huge phenomenon about which I knew next to nothing. I wondered how the entire country could be in love with country music, and yet I knew nothing about it. My head wasn't totally buried in the sand. Or was it? I did a bit of research and I saw that country music is a huge part of America and has an enormous following. It was time to find out why.

I spent hours listening to country radio and researching who should be in the book. Simultaneously, I started to formulate the list of questions for my interview. What did the singers think about the genre, and why it is such a part of the essence of American culture? I'd noticed that religion and tradition play a huge part. I wondered whether they had a clear moment when they knew they had to be a singer. What songs did they love? What inspired them? Somewhere along the way, the book began to take shape. And my list of 50 artists was born.

Then came the hard part: getting in contact with the country singers. I wasn't sure where to start. So I contacted them all. I called, I emailed, again and again, conducting a kind of a mini-stalking operation. Often, there was no response, but once in while someone replied. Tracking down these stars became an obsession. The whole thing became an obsession. As I learned the history and the ins and outs of the country music scene, past and present, I became fascinated and enchanted by what I found.

I spent days traveling to beautiful pockets of the country I'd never visited before.

I went to a decommissioned Tennessee prison, an old ironworks factory, the *Hee Haw* TV studio, and even spent time in George Jones's basement. I met all the branches of the local Nashville military, who came together for a shoot, and honestly, I'll bet I could navigate my way around the Grand Ole Opry with my eyes closed.

Music City—as Nashville is called over the loudspeaker when you land at the airport—became my second home. I knew where to get free Wi-Fi, where to buy the best "meat and three," and where to procure the best wholesale couture in the country. I met some lovely people who guided me and helped me navigate the town. Many times they were shocked that I wasn't getting through to some of the artists and took it upon themselves to call them right there and then.

As I put down my camera after 50 shoots in 9 months, my feelings are bittersweet. I will miss visiting Nashville regularly to meet the artists and people who trusted me and allowed me to shoot them. I am thankful that I had the chance to dip into a world that I knew nothing about. I wonder sometimes if I bit off more than I could chew, as 9 months is hardly enough time to really understand the complexity of an art form. However, I view this project more as a snapshot and a celebration of country music today. My greatest discovery? Country music, like ancient cave paintings or poetry, is a collective way to laugh, cry, mourn, and, most important, to tell the stories that make us who we are.

—Melanie Dunea

DESCRIBE YOUR ULTIMATE MUSICAL PERFORMANCE.

A behind-closed-doors jam session in Jamaica with Bob Marley and the original Wailers . . . the kind of jam session you record and 50 years later, they find it in a closet—and can't believe it really exists.

HAVE YOU EVER HEARD A SONG YOU WISH THAT YOU HAD WRITTEN?

Every day. Every time I listen to a Jackson Browne record.

WAS THERE A MOMENT WHEN YOU KNEW YOU HAD TO BE A COUNTRY MUSICIAN?

Really, this is just what I've always done. You don't decide you're going to be a musician instead of leading a normal life. You're called, and you go—and sometimes you just never go back.

DO YOU HAVE ANY SPECIAL THING YOU DO BEFORE YOU PERFORM?

The Vibe Room . . . getting all the guys together. We crank up the music and shake off the day so we can remember why we're there.

IF YOU WEREN'T A SINGER, WHAT WOULD YOU HAVE BEEN?

I can't imagine, but I'd like to think it would be something creative.

IF YOU COULD THANK GOD IN PERSON FOR ONE THING, WHAT WOULD IT BE?

The power music has in people's lives. The idea that you can hear a song, and it tells you something about your life . . . or how you feel when you don't have the words. It lets you understand in a way I don't think anything else can.

WHAT MAKES COUNTRY MUSIC THE HEART AND SOUL OF AMERICA?

The fans.

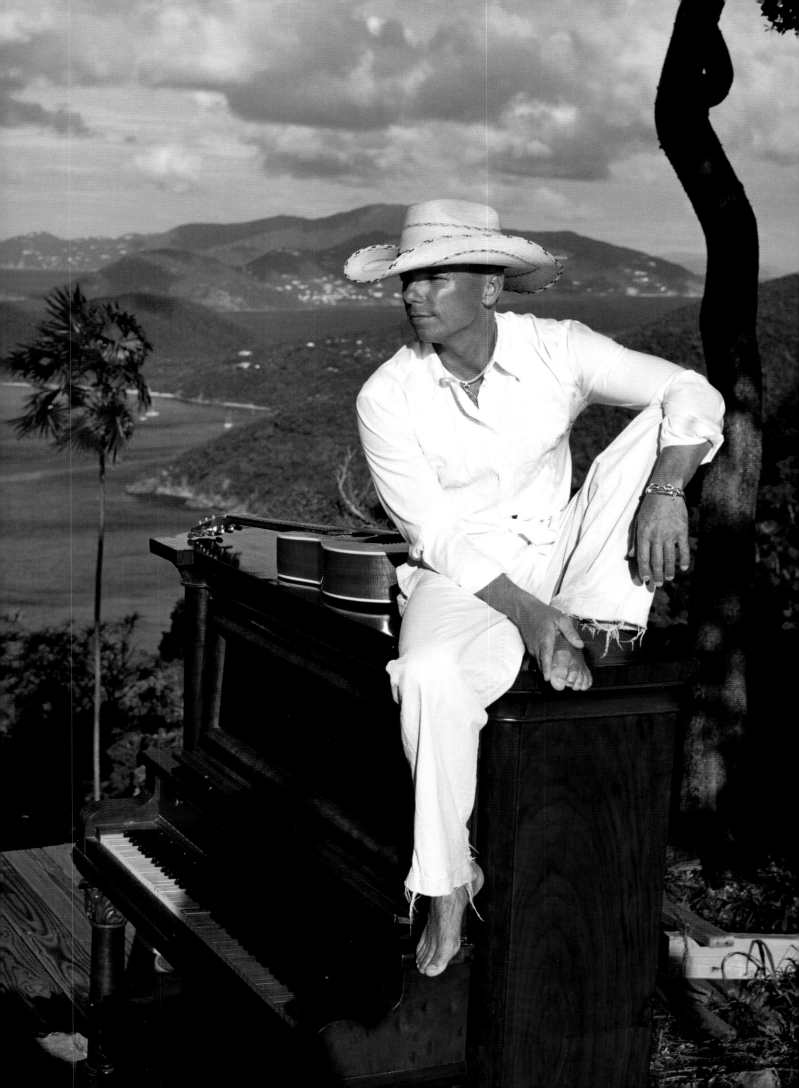

DESCRIBE YOUR ULTIMATE MUSICAL PERFORMANCE.

I'm getting to do the Ryman Auditorium, which is one of my dreams. I like to think of myself as one of the outlaws . . . I would love to do a performance in a women's prison. It would be so amazing to hear the prisoners' stories, having an artist come in that could relate to them through their music . . . I would have just some kick-ass chicks come and perform with me . . . Jessi Colter, Emmylou Harris, Gretchen Wilson.

HAVE YOU EVER HEARD A SONG YOU WISH THAT YOU HAD WRITTEN?

"The Way I Am," by Merle Haggard. "Red Dirt Girl," by Emmylou Harris.

WAS THERE A MOMENT WHEN YOU KNEW YOU HAD TO BE A COUNTRY MUSICIAN?

You know, I went to the Garth Brooks concert when I was 10 years old. I looked out at the crowd watching Garth, and I had tears rolling down my face, and something clicked; I was that overwhelmed. I knew that something would come out of that.

DO YOU HAVE ANY SPECIAL THING YOU DO BEFORE YOU PERFORM?

I watch videos. I love watching live DVDs. I'm really into Elvis. I am just now falling in love with him. I turn to Beyoncé, Tina Turner, artists that I love, to get inspired. I have a stage persona just like Beyoncé.

IF YOU WEREN'T A SINGER, WHAT WOULD YOU HAVE BEEN?

I have no other skills . . . hell, I might be in prison.

IF YOU COULD THANK GOD IN PERSON FOR ONE THING, WHAT WOULD IT BE?

There are so many things that I want to thank Him for . . . He knows what they are.

WHAT MAKES COUNTRY MUSIC THE HEART AND SOUL OF AMERICA?

Country music tells the truth. Pure and simple. It may not always paint the prettiest picture when it deals with heartbreak, drinking, and cheating, but those are parts of real life. Country music is real.

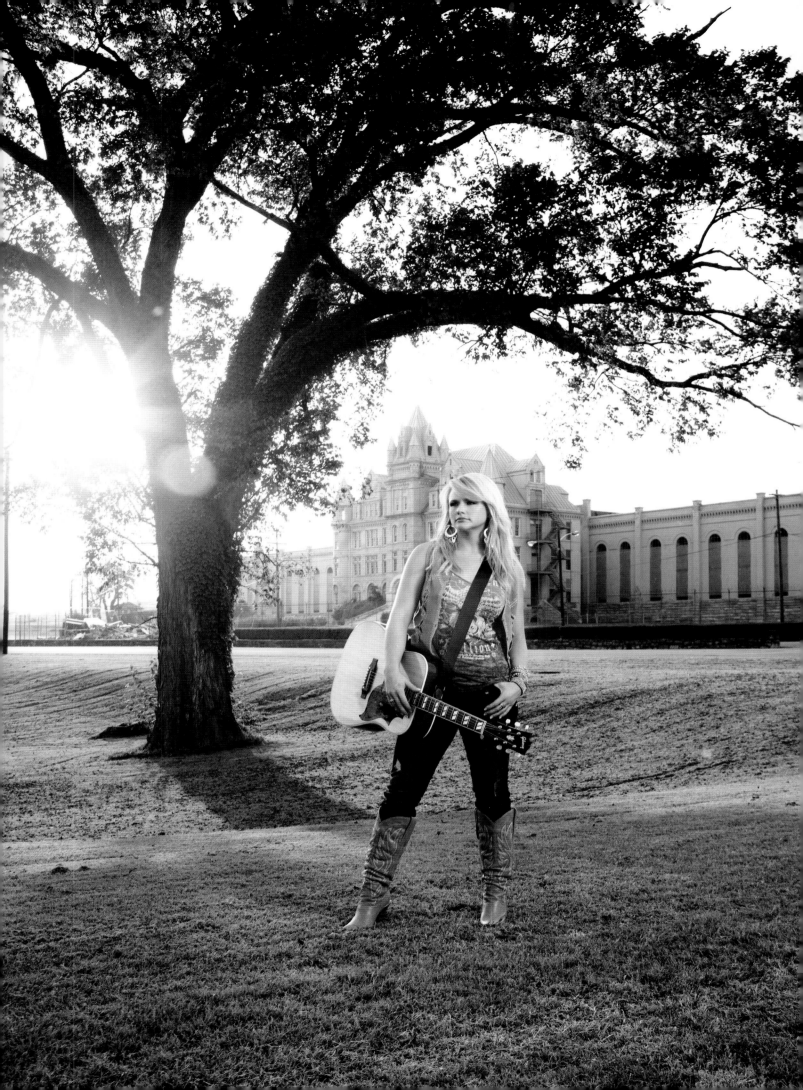

JIM LAUDERDALE

DESCRIBE YOUR ULTIMATE MUSICAL PERFORMANCE.

At the Ryman Auditorium. I don't know who the accompanying musicians would be, 'cause I have so many musicians that I like, it would be a cacophony of music.

HAVE YOU EVER HEARD A SONG YOU WISH THAT YOU HAD WRITTEN?

"Hickory Wind," by Gram Parsons.

WAS THERE A MOMENT WHEN YOU KNEW YOU HAD TO BE A COUNTRY MUSICIAN?

I had been singing bluegrass music as a teenager, and when I heard George Jones, I knew I had to add country to my sound.

DO YOU HAVE ANY SPECIAL THING YOU DO BEFORE YOU PERFORM?

I like to be able to sing and play the guitar to warm up, but sometimes there isn't enough time.

IF YOU WEREN'T A SINGER, WHAT WOULD YOU HAVE BEEN?

A tai chi master.

IF YOU COULD THANK GOD IN PERSON FOR ONE THING, WHAT WOULD IT BE?

Life.

WHAT MAKES COUNTRY MUSIC THE HEART AND SOUL OF AMERICA?

Because it's honest and real and it does have heart and soul.

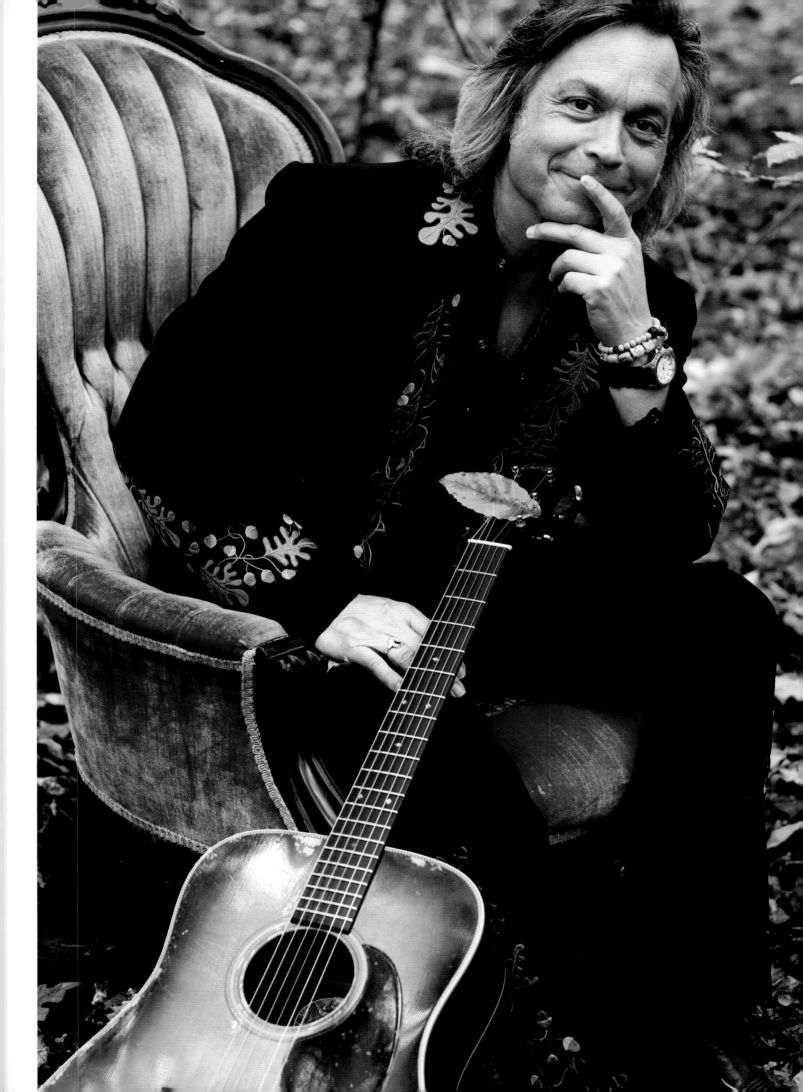

CHARLEY PRIDE

DESCRIBE YOUR ULTIMATE MUSICAL PERFORMANCE.

There are so many artists that I'd love to play with. It's kind of hard to answer. It's like when someone asks me which of my songs I like the best—it's the one I am singing at the moment. The only thing I would really like is to have a performance where my mother, who passed a long time ago, could be part of it, for her to be sitting there and watching me perform.

HAVE YOU EVER HEARD A SONG YOU WISH THAT YOU HAD WRITTEN?

There are so many of them. "Help Me Make It Through the Night" is one. All of Kris Kristofferson's songs and all of Ben Peters's songs.

WAS THERE A MOMENT WHEN YOU KNEW YOU HAD TO BE A COUNTRY MUSICIAN?

My dream was to go to the major leagues as a baseball player and break all of the records by the time I was 35. Every kid has a dream, and that was mine. That was my plan. There wasn't one particular moment for music. I starting singing and performing, and little by little, it progressed. Whatever I do, I want to be the best at it.

DO YOU HAVE ANY SPECIAL THING YOU DO BEFORE YOU PERFORM?

No.

IF YOU WEREN'T A SINGER, WHAT WOULD YOU HAVE BEEN?

Since the baseball didn't work out, I think I would have done something in the entertainment field.

IF YOU COULD THANK GOD IN PERSON FOR ONE THING, WHAT WOULD IT BE?

Blessing me.

WHAT MAKES COUNTRY MUSIC THE HEART AND SOUL OF AMERICA?

With country music, you can find a song for any mood you are in or that fits any situation. It's the type of music that specializes in the lyrics, not the music around it.

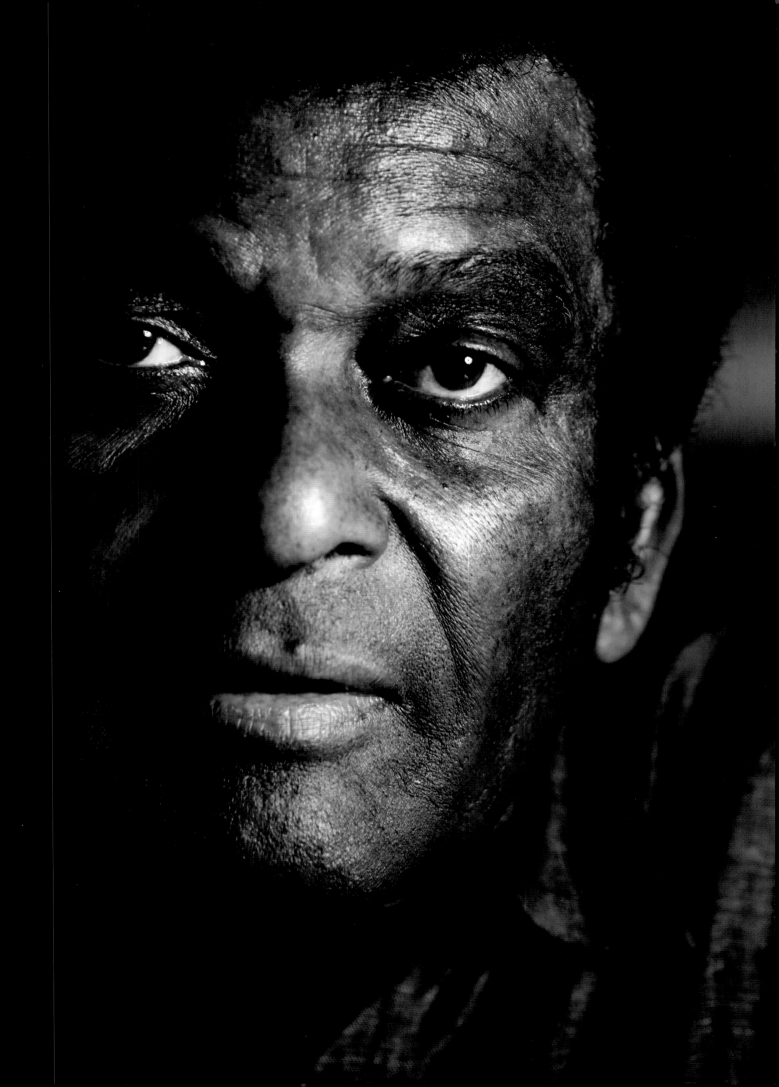

DESCRIBE YOUR ULTIMATE MUSICAL PERFORMANCE.

Someday I would love to be a stadium performer. I have been a part of other artists' stadium shows, but so far, I have never had one of my own. I bet that's the best feeling in the world, to have that many people all there to see you! I would love to be like U2 or the Rolling Stones and be able to play to massive stadiums for the rest of my life!

HAVE YOU EVER HEARD A SONG YOU WISH THAT YOU HAD WRITTEN?

It's really hard to pick just one because there are so many melodies and genius lyrics. But if I had to give a general idea, I would pick something classical, something by Beethoven or Chopin that really shaped every form of music after it. Those were the composers of music-altering songs.

WAS THERE A MOMENT WHEN YOU KNEW YOU HAD TO BE A COUNTRY MUSICIAN?

Being a country music singer has been in my mind ever since I was a little girl singing in my mom's car. There was never a defining moment when I decided that this was the life I would lead . . . I'm much too practical for that kind of thinking. But I'm so grateful that I'm here now.

DO YOU HAVE ANY SPECIAL THING YOU DO BEFORE YOU PERFORM?

My band members and I get together about 15 minutes before showtime to hang out. We always say a prayer before we walk onstage.

IF YOU WEREN'T A SINGER, WHAT WOULD YOU HAVE BEEN?

I went to college to be a broadcast journalist. You might've seen me on the news.

IF YOU COULD THANK GOD IN PERSON FOR ONE THING, WHAT WOULD IT BE?

Someday, I plan to thank God for a lot of things. Mostly, I would thank Him for letting me be born into such a wonderful family in America. They are in every fiber of me and shaped my life so much. But I know I'll spend the rest of eternity thanking God for everything else!

WHAT MAKES COUNTRY MUSIC THE HEART AND SOUL OF AMERICA?

It's honest. Everyone can relate to it because country music is about life.

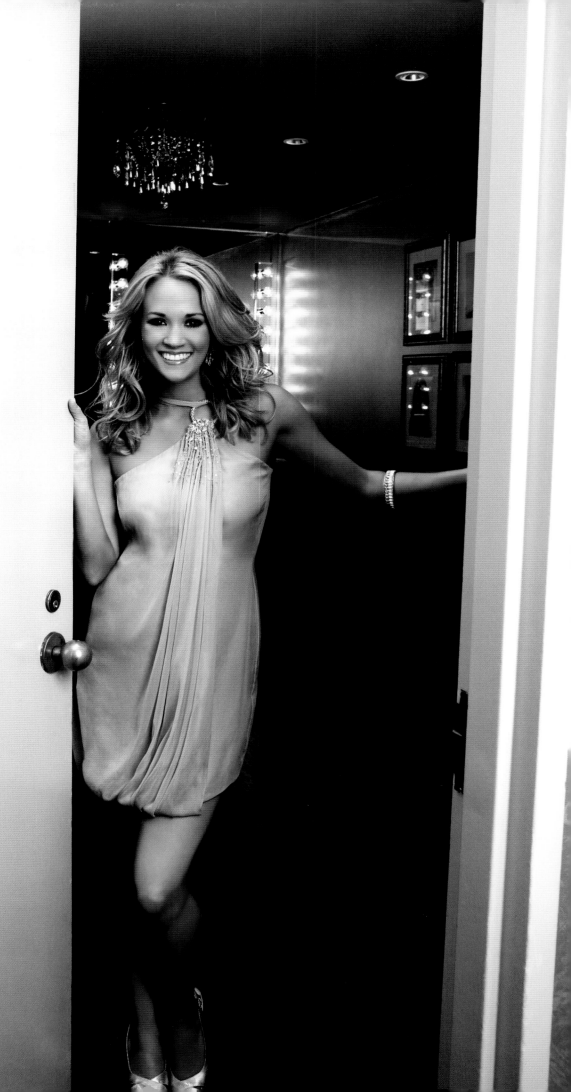

DESCRIBE YOUR ULTIMATE MUSICAL PERFORMANCE.
Anywhere in America with my band.

HAVE YOU EVER HEARD A SONG YOU WISH THAT YOU HAD WRITTEN?
Yes: "The Weekend," "I Saw God Today," "I Hope You Dance," "Because of You," "He Stopped Loving Her Today"—just to name a few.

WAS THERE A MOMENT WHEN YOU KNEW YOU HAD TO BE A COUNTRY MUSICIAN?
No, but I always loved to sing. It's also where I got the most attention . . . the good kind, I mean.

DO YOU HAVE ANY SPECIAL THING YOU DO BEFORE YOU PERFORM?
I warm up my voice with my vocal exercises, pinky up with my band and crew, and eagerly get on stage.

IF YOU WEREN'T A SINGER, WHAT WOULD YOU HAVE BEEN?
I would have wanted to be in some part of the entertainment business—actor, writer, director . . .

IF YOU COULD THANK GOD IN PERSON FOR ONE THING, WHAT WOULD IT BE?
For loving me.

WHAT MAKES COUNTRY MUSIC THE HEART AND SOUL OF AMERICA?
It's music that you can relate to. Any song I sing, there is someone out there who thinks that song was written just for them.

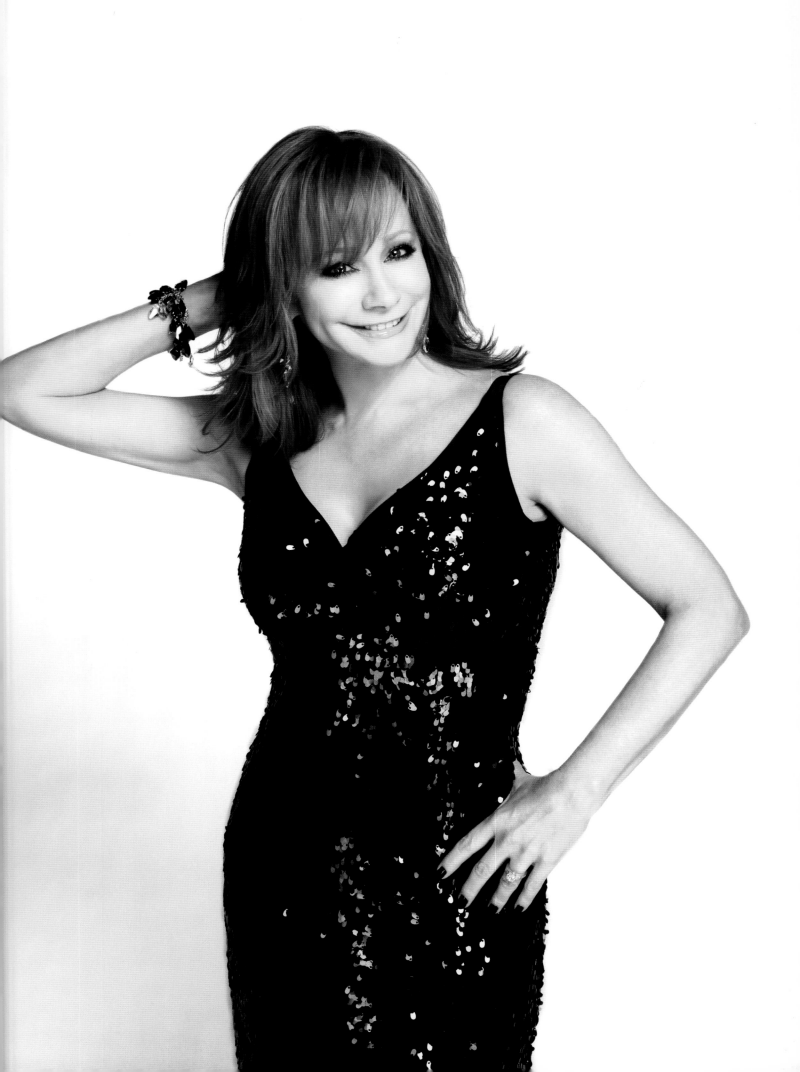

 HEIDI

WAS THERE A MOMENT WHEN YOU KNEW YOU HAD TO BE A COUNTRY MUSICIAN?

I was 6 years old. First time on stage, I just walked up there and asked if I could sing with the band. Got the applause . . . and I was done for!

NEWFIELD

DESCRIBE YOUR ULTIMATE MUSICAL PERFORMANCE.
A packed Madison Square Garden with Bruce Springsteen, or Bonnie Raitt, or Tom Petty, or Willie Nelson.

HAVE YOU EVER HEARD A SONG YOU WISH THAT YOU HAD WRITTEN?
"I Can't Make You Love Me."

DO YOU HAVE ANY SPECIAL THING YOU DO BEFORE YOU PERFORM?
I do vocal warmups with a few band members . . . run through a few songs . . . and say a little prayer. We all gather before we all hop onstage and high-five and wish each other a great show.

IF YOU WEREN'T A SINGER, WHAT WOULD YOU HAVE BEEN?
I can't imagine not being a singer. But I would still be a songwriter . . . and maybe a photographer . . . or an equine vet!

IF YOU COULD THANK GOD IN PERSON FOR ONE THING, WHAT WOULD IT BE?
Love.

WHAT MAKES COUNTRY MUSIC THE HEART AND SOUL OF AMERICA?
The story behind the songs. It's the music of life, of real situations and relationships. A great country song hits me where I live.

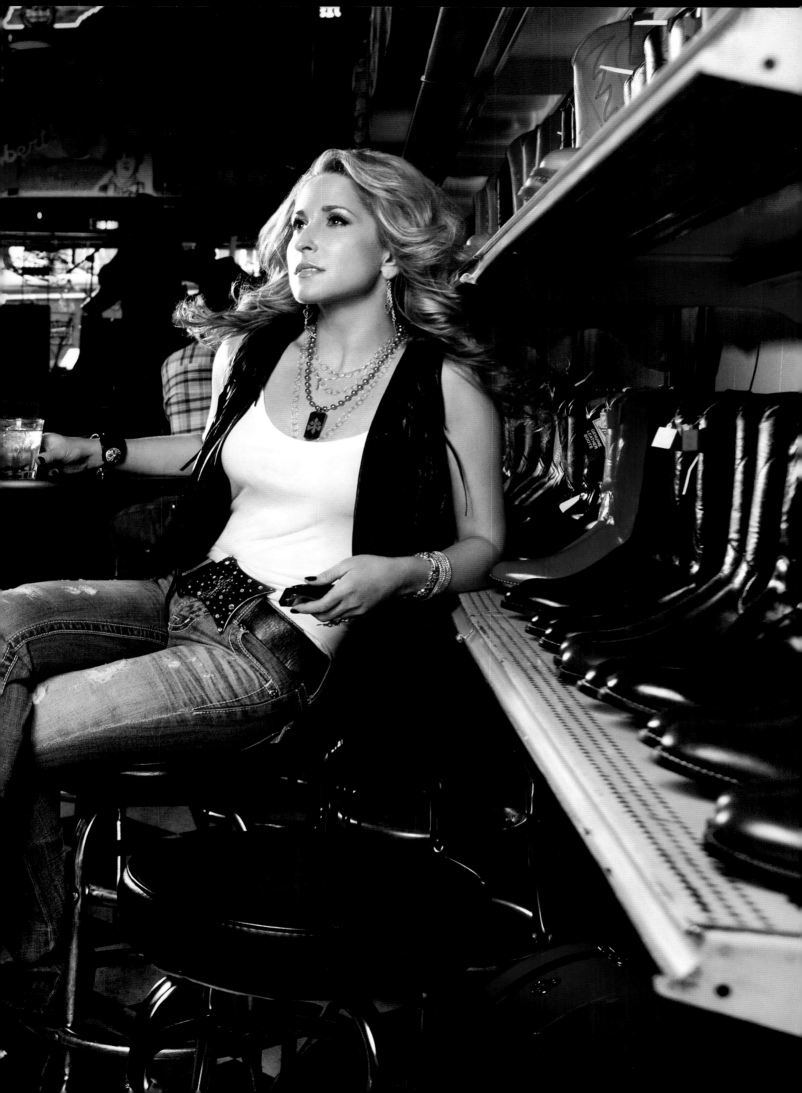

RAY BENSON

DESCRIBE YOUR ULTIMATE MUSICAL PERFORMANCE.

I have already had and continue to have my ultimate musical performances with Willie. But there is one I haven't had. I have done duets with everyone except Tony Bennett, and I don't care where it happens, as long as it's just me and Tony.

HAVE YOU EVER HEARD A SONG YOU WISH THAT YOU HAD WRITTEN?

Hundreds. The one that comes to mind now is a Roger Miller song, "The Last Word in Lonesome Is Me."

WAS THERE A MOMENT WHEN YOU KNEW YOU HAD TO BE A COUNTRY MUSICIAN?

I started performing when I was 9, and we were professional by the time I was 11. I was discouraged when I started (which is what I do to young people who want to sing, by the way). The actual moment came to while I was standing on a New York City subway platform. It was 1969.

DO YOU HAVE ANY SPECIAL THING YOU DO BEFORE YOU PERFORM?

I smoke pot.

IF YOU WEREN'T A SINGER, WHAT WOULD YOU HAVE BEEN?

A director/writer, and when that failed, a chef.

IF YOU COULD THANK GOD IN PERSON FOR ONE THING, WHAT WOULD IT BE?

For my two kids. That came out pretty good.

WHAT MAKES COUNTRY MUSIC THE HEART AND SOUL OF AMERICA?

Because it is purely American, and that's why I like it. But I don't like all country music.

DESCRIBE YOUR ULTIMATE MUSICAL PERFORMANCE.

There would be tons of lights, fog, and amazing dramatic sets. It would be a real theatrical production. I would love it to take place somewhere really grand, like Wembley Stadium in London.

HAVE YOU EVER HEARD A SONG YOU WISH THAT YOU HAD WRITTEN?

I wish that I had written a Christmas song or "The Star-Spangled Banner." A song that is really personal and everyone is familiar with.

WAS THERE A MOMENT WHEN YOU KNEW YOU HAD TO BE A COUNTRY MUSICIAN?

I've always loved country music! I grew up singing with my family, and when I moved to London to study singing and dancing, my mom would send me my favorite country CDs because there wasn't a lot of country music in London. I sang with my family a ton when I was younger, and some people would even call us the blonde Osmonds.

DO YOU HAVE ANY SPECIAL THING YOU DO BEFORE YOU PERFORM?

I always warm up with the band, and we play a song of ours in a really heavy metal version. I eat Hot Tamales candies, which open up my throat, and then I have some Sour Patch Kids, because they are good!

IF YOU WEREN'T A SINGER, WHAT WOULD YOU HAVE BEEN?

That's hard to answer because I couldn't imagine my life any other way. I've always wanted to be a performer and have known that for as long as I can remember. If I'm not singing, I love dancing and acting and feel so fortunate to be able to do all of those things already!

IF YOU COULD THANK GOD IN PERSON FOR ONE THING, WHAT WOULD IT BE?

I thank God for giving me an amazing family. I also think that I believe in myself because God believes in me. At times when I might not feel very confident, God (He or She) gives me to courage to pretend to feel confident.

WHAT MAKES COUNTRY MUSIC THE HEART AND SOUL OF AMERICA?

Everyone can relate to country music because of the stories it tells, no matter what their situation in life. The beauty is that one song might touch one person and one song might touch a ton of people.

DESCRIBE YOUR ULTIMATE MUSICAL PERFORMANCE.
I would probably like to go to a Shriners Hospital for Children and do a concert at the hospital. I would play with my band.

HAVE YOU EVER HEARD A SONG YOU WISH THAT YOU HAD WRITTEN?
I wouldn't know where to begin. "Chiseled in Stone," by Vern Gosdin—great song. So many great songs.

WAS THERE A MOMENT WHEN YOU KNEW YOU HAD TO BE A COUNTRY MUSICIAN?
You know, I've been doing this so long, it's hard to say. I mean, it's just a natural way. I started when I was 6 or 7, playing different instruments.

DO YOU HAVE ANY SPECIAL THING YOU DO BEFORE YOU PERFORM?
Well, when I was younger, I used to drink whiskey, but I don't do that much anymore.

IF YOU WEREN'T A SINGER, WHAT WOULD YOU HAVE BEEN?
I've been more than a singer in my lifetime. I was a ventriloquist and magician since I was 15, and at one time I toured with the chimp and tigers and jaguars and cougars and did magic and music together.

IF YOU COULD THANK GOD IN PERSON FOR ONE THING, WHAT WOULD IT BE?
I'm not sure that I believe in the God that you're wanting me to think of.

WHAT MAKES COUNTRY MUSIC THE HEART AND SOUL OF AMERICA?
Real songs about real life and about real people in real life situations, more so than music with a beat you can dance to. It's people living out their heartaches, happy times, bad times. There's no other musical form that dwells so deeply in your soul as country music, other than blues, but blues is all sad, and country music is both.

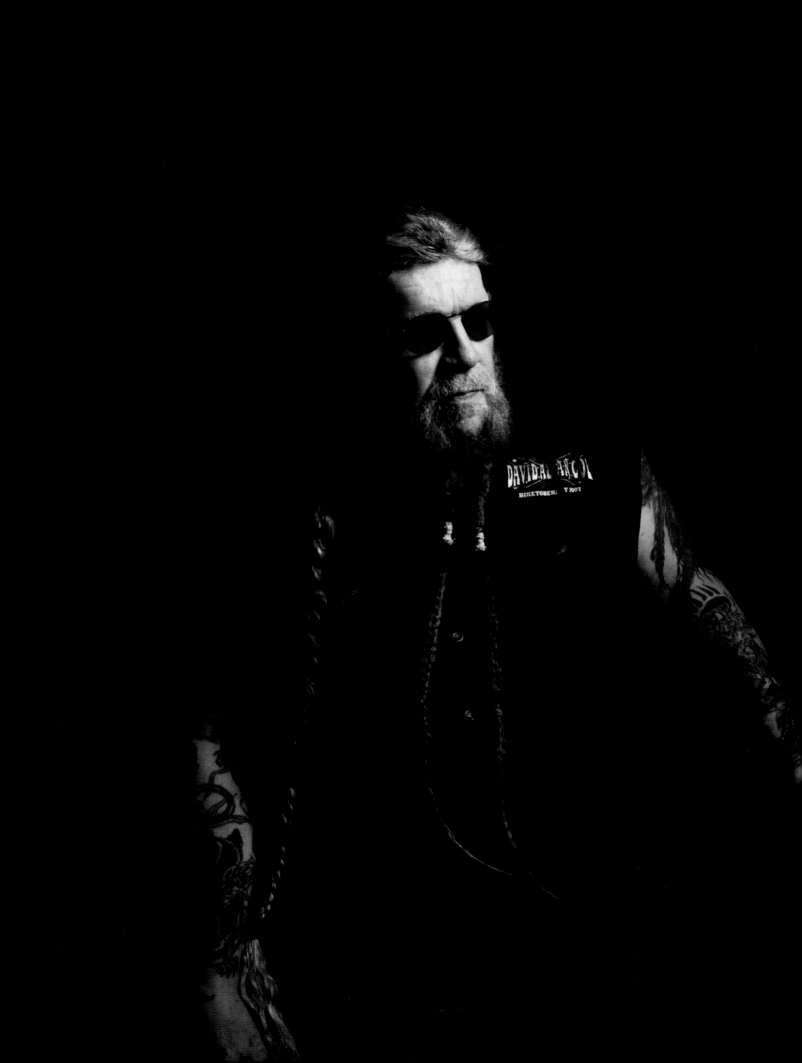

TRACE ADKINS

DESCRIBE YOUR ULTIMATE MUSICAL PERFORMANCE.

I would rather you ask me this question again in 40 years, and I will tell you what my ultimate musical performance was instead of limiting my answer to what my feeble mind could imagine now.

HAVE YOU EVER HEARD A SONG YOU WISH THAT YOU HAD WRITTEN?

I have said for many years that I wish I had recorded and written a song that Alan Jackson recorded a few years ago—"Between the Devil and Me."

WAS THERE A MOMENT WHEN YOU KNEW YOU HAD TO BE A COUNTRY MUSICIAN?

I recall a moment when I realized I enjoy entertaining people. I can't really remember having an actual epiphany, but over time I became more confident and comfortable onstage.

DO YOU HAVE ANY SPECIAL THING YOU DO BEFORE YOU PERFORM?

Not anymore. I used to have a Marlboro before I went on stage. Now I just hit it. I don't have any superstitious rituals that I go through.

IF YOU WEREN'T A SINGER, WHAT WOULD YOU HAVE BEEN?

Probably a tool pusher . . . working on a drill rig.

IF YOU COULD THANK GOD IN PERSON FOR ONE THING, WHAT WOULD IT BE?

I thank God for the people who have loved me.

WHAT MAKES COUNTRY MUSIC THE HEART AND SOUL OF AMERICA?

It's blue-collar music, and whether they want to accept it or not this country is run by the blue-collar majority; it's not the white-collar elites.

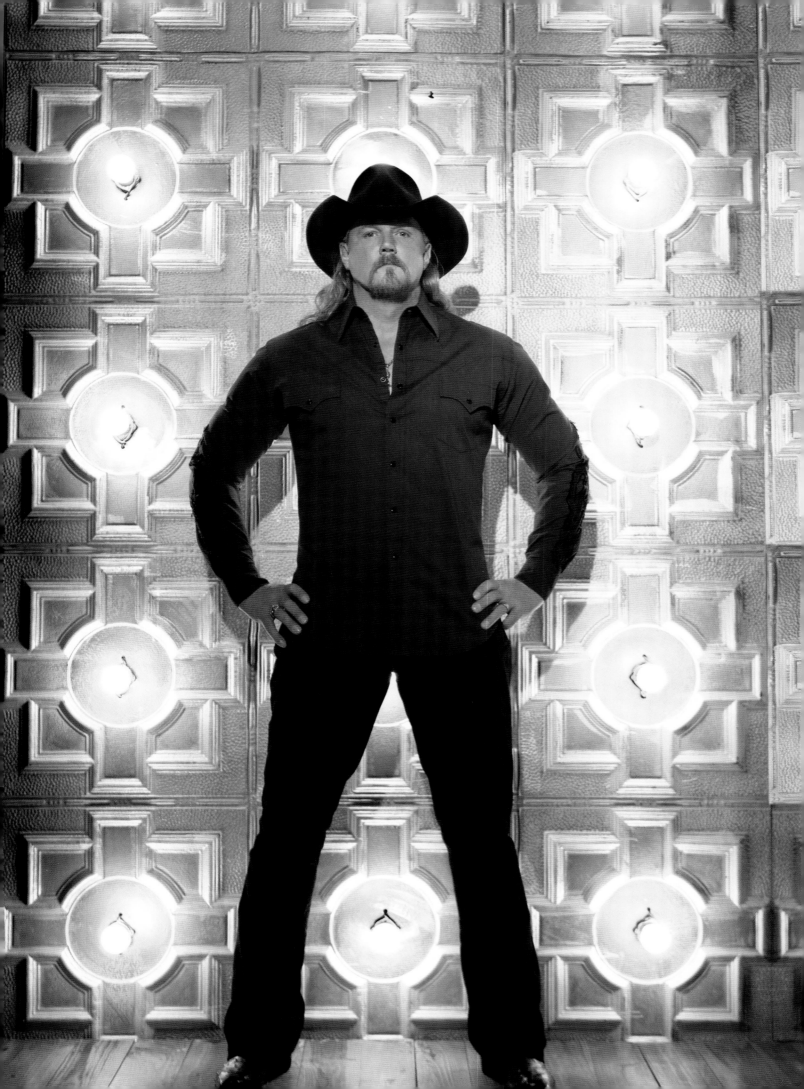

MARTINA McBRIDE

DESCRIBE YOUR ULTIMATE MUSICAL PERFORMANCE.

I love singing in the great halls that were really meant for experiencing music—Radio City Music Hall, Carnegie Hall, the Schermerhorn, for example. My dream would be to sing in one of these in a beautiful gown with a magnificent orchestra. Because the acoustics are so outstanding, you can really do things vocally that you can't do in an arena. Subtleties, nuances, dynamics, all become effortless. And people are there to really listen.

HAVE YOU EVER HEARD A SONG YOU WISH THAT YOU HAD WRITTEN?

I have heard many songs I wish I had written. "Over the Rainbow" comes to mind. "Yesterday" is another.

WAS THERE A MOMENT WHEN YOU KNEW YOU HAD TO BE A COUNTRY MUSICIAN?

I grew up singing country music and then went on to sing pop, R&B, and rock. One night, after having been out of the country genre for a while, I was singing with my dad's country band and it just hit me. Country music felt like home to me. I had always dreamed of getting a record deal and being an artist, but I had always held back on really going for it because I just wasn't sure what direction I wanted to take, musically. I told my husband that night that I wanted to move to Nashville, and we moved 2 months later.

DO YOU HAVE ANY SPECIAL THING YOU DO BEFORE YOU PERFORM?

I like to have some time to myself before I perform. I warm up, think about the show, get in the right headspace.

IF YOU WEREN'T A SINGER, WHAT WOULD YOU HAVE BEEN?

I don't really know what I would have been if I hadn't been a singer. I never really dreamed of doing anything else. I did always think it would be fun to own a restaurant or be a party planner!

IF YOU COULD THANK GOD IN PERSON FOR ONE THING, WHAT WOULD IT BE?

I don't know if there is any way to narrow it down to the one thing you would thank God for in person. I thank Him daily for so many things. My kids, my husband, our health, our freedom, the fact that we have the ability to appreciate all these things to the fullest. I guess, all that aside, I am extremely grateful for the gift of voice that He gave me. It's such a wonderful gift and I'm so blessed by it. I love to sing so much. And I love to make people happy with my voice. So, as gifts go, He gave me a pretty cool one! Better than, say, the gift of being organized, which I did not get!

WHAT MAKES COUNTRY MUSIC THE HEART AND SOUL OF AMERICA?

Country music is familiar to me in the way all the things you grew up with, all the things that shaped you, that are part of your earliest memories, are familiar. It just speaks to me. I think it's honest and true, at least the kind of country music I admire. And I think there's just a frankness about it. It doesn't hide behind anything. And some of it, the songs of Kris Kristofferson or Merle Haggard, for example, is just pure poetry.

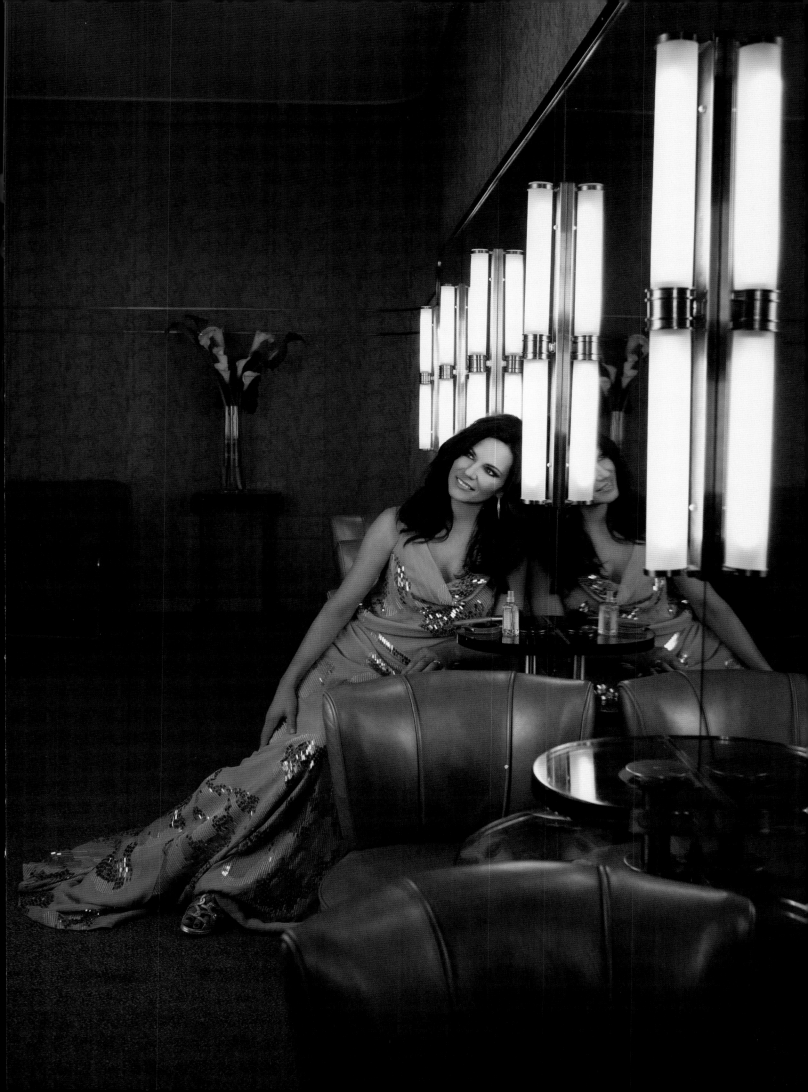

JOHN RICH

DESCRIBE YOUR ULTIMATE MUSICAL PERFORMANCE.

It would be in Las Vegas with the Rat Pack (Sinatra, Dean Martin, Sammy Davis Jr.) and the Outlaws (Willie, Waylon, Cash, Kristofferson). The band would be Bob Wills's Texas Playboys. Now that's a jam!

HAVE YOU EVER HEARD A SONG YOU WISH THAT YOU HAD WRITTEN?

I wish I'd written "Hotel California." It has among the most creative melodies, lyrics, and chord progressions of any song in the past 40 years.

WAS THERE A MOMENT WHEN YOU KNEW YOU HAD TO BE A COUNTRY MUSICIAN?

When I was in the ninth grade, there was a girl named Ginny Hogan, and she was a junior. She was dating a senior, and the only thing I could think of to get her attention was to write her a country song. So I did. It worked! If any guy tells you they initially learned to play the guitar for any other reason than to meet girls, they're full of it.

DO YOU HAVE ANY SPECIAL THING YOU DO BEFORE YOU PERFORM?

I have a shot (or two) of Crown Royal (chilled), I sing Johnny Cash songs for about 30 minutes on the bus, and then I put on the rhinestone jeans that my Granny Rich makes for me, and we go tear a hole in the stage!

IF YOU WEREN'T A SINGER, WHAT WOULD YOU HAVE BEEN?

If I weren't a successful country singer-songwriter, I would be a struggling country singer-songwriter.

IF YOU COULD THANK GOD IN PERSON FOR ONE THING, WHAT WOULD IT BE?

Thank You for sending Your Son to die for our sins and for letting me be born in the United States of America.

WHAT MAKES COUNTRY MUSIC THE HEART AND SOUL OF AMERICA?

Country music is the only music that speaks to literally everything in an American's life. From love to loss, from the party to the grave, from politics and patriotism, personal angels and demons, to makin' babies and raisin' babies, country music has no boundaries. That's why the masses in America tune in to their local country station every day. It's real music for real people sung by real artists.

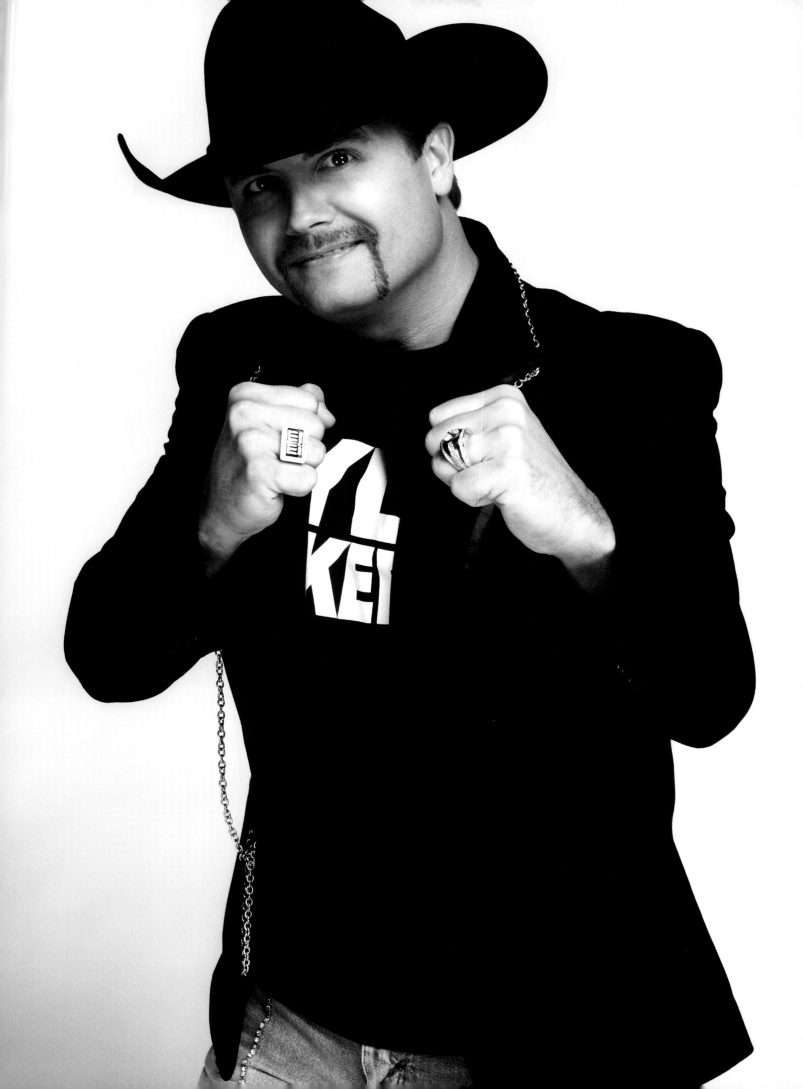

Barbara ★

WHAT MAKES COUNTRY MUSIC THE HEART AND SOUL OF AMERICA?

Country music is a love and passion that has taken me all over the world. The songs are powerful because they are real and not contrived, earthy, from someone's heart to other people's hearts. Country music tells it like it truly is, speaks volumes, and it's lasting. I always say, if you think you don't like country music, then you haven't really listened to it. There is a lot of variety within it; it's very versatile and has a rich history.

Mandrell

DESCRIBE YOUR ULTIMATE MUSICAL PERFORMANCE.

It was an immensely profound honor to perform in front of a million people and to see all the faces of the military in uniform with their families when I played a tribute to Gulf War soldiers at the Lincoln Memorial in DC. I was lucky to be a civilian teenager in Vietnam, where I spent time with the Mandrell Family Band performing for troops. That experience had a lasting effect on me and holds a special place in my heart and mind. I was very lucky to be born in the USA and also to have a father, father-in-law, and husband fight for and defend our freedom. It was God and the public that gave me my name and the ability to experience my heart's desires. The public has given me more than I could have ever imagined possible.

HAVE YOU EVER HEARD A SONG YOU WISH THAT YOU HAD WRITTEN?

A lot of them. "Battle Hymn of the Republic" is my favorite song. I actually performed it in my HBO special, *The Lady Is a Champ!* I have a framed quote of the line "In the beauty of the lilies . . ." in Julia Ward Howe's handwriting that my husband, Ken, gave me.

WAS THERE A MOMENT WHEN YOU KNEW YOU HAD TO BE A COUNTRY MUSICIAN?

I starting playing steel guitar and saxophone at age 10, and I started working professionally 6 months later. I never had aspirations. I was just doing something I loved. Then I quit to become a navy wife. My defining moment came 9 years later at the Grand Ole Opry with my daddy, sitting in the audience. I knew that I wanted to be onstage performing. I turned to him and said I wasn't cut out to be in the audience and asked him if he would manage me.

DO YOU HAVE ANY SPECIAL THING YOU DO BEFORE YOU PERFORM?

I always pray before a show. And when the music starts booming, I always stomp my feet—left foot stomp, right foot stomp, left. I've never really thought about it before. It's kind of like an engine. I always take some time getting my head in the right place, ready to take charge. The audience wants someone in charge when they take the stage.

IF YOU WEREN'T A SINGER, WHAT WOULD YOU HAVE BEEN?

My first reaction to this question is always to say a navy pilot, but in reality it would probably have to be something in front of the public. When I was young, a teacher of mine told my parents that whatever I did, it would have something to do with the public. Maybe a cruise director or something. I have prayed for my children to be leaders, not followers, not afraid to get up in front of people. Thankfully, they all enjoy getting up and talking in front of people.

IF YOU COULD THANK GOD IN PERSON FOR ONE THING, WHAT WOULD IT BE?

For being born into a home that served the Lord and where I got to know Jesus Christ.

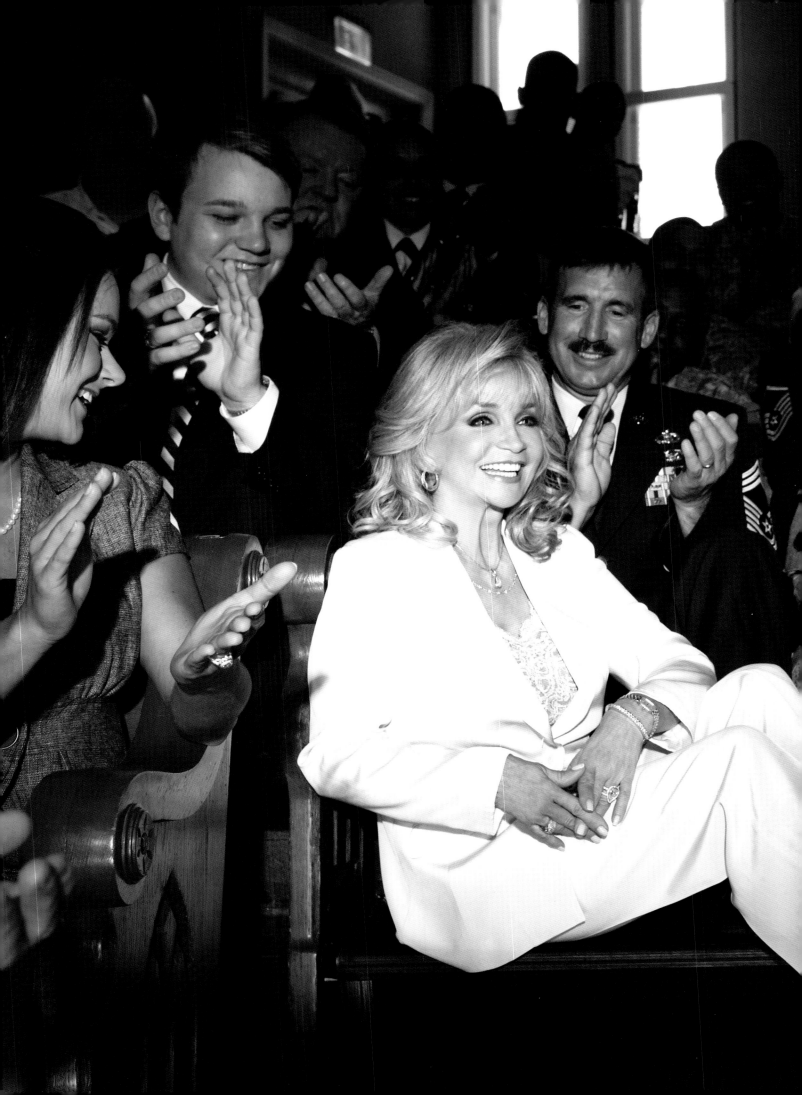

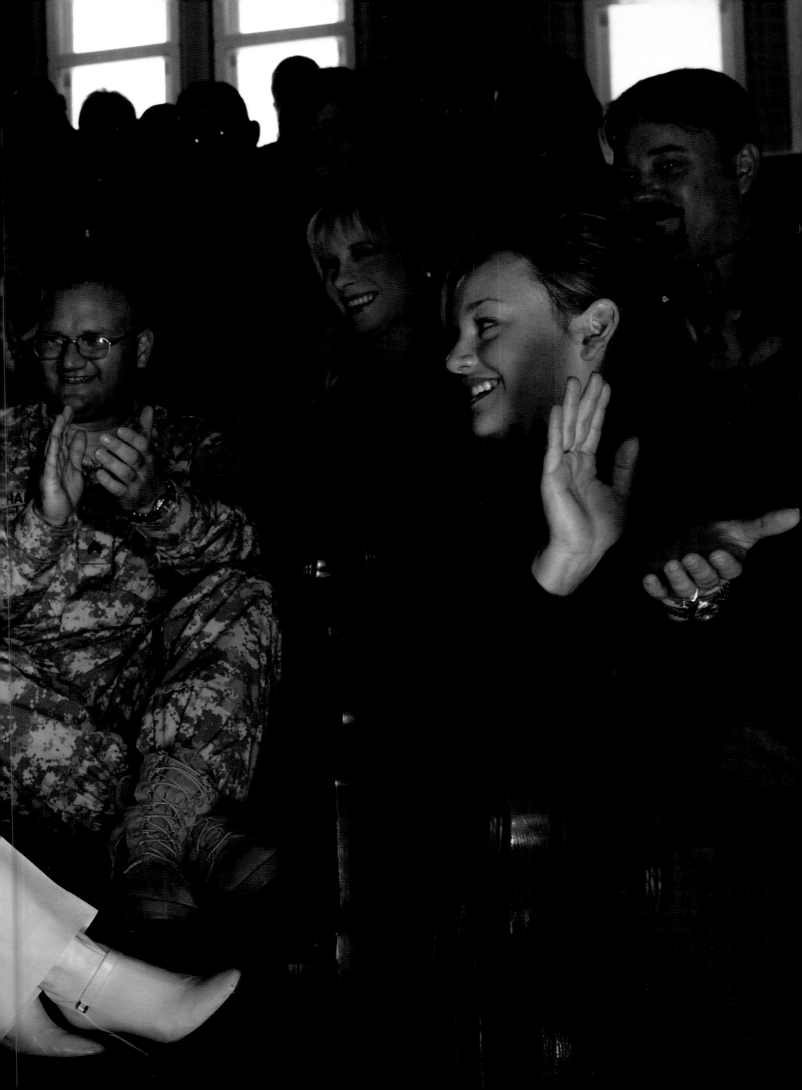

DESCRIBE YOUR ULTIMATE MUSICAL PERFORMANCE.

All my performances for the American military. During my career I made 13 trips to Europe wherever there was an American military base. I made three trips to Vietnam: 1964, '65 and '66. The most appreciative audiences I've ever worked for in my life have been overseas, because they figure if you come that far, they better listen, and you can do nothing wrong. Greatest audience in the world.

HAVE YOU EVER HEARD A SONG YOU WISH THAT YOU HAD WRITTEN?

I've heard a lot of songs that I wish I had written. It is tough, because all these people in country music are my friends, and I don't mean to offend anyone by the answers I give, but I have to be myself and I think my favorite all-time song is "Mama's Hungry Eyes," by Merle Haggard, and if you haven't heard that song, you've missed a lot. It wasn't a hit.

WAS THERE A MOMENT WHEN YOU KNEW YOU HAD TO BE A COUNTRY MUSICIAN?

I've known all my life. When I was in high school, I knew I wanted to be like some people who were favorites of mine, at home; they were on local radio stations, back in West Virginia. I hung around with those people hoping they'd let me sing with them.

DO YOU HAVE ANY SPECIAL THING YOU DO BEFORE YOU PERFORM?

No, ma'am.

IF YOU WEREN'T A SINGER, WHAT WOULD YOU HAVE BEEN?

Well, if I had not been a country singer, I believe I would have been a jockey. Not a disk jockey, just a jockey.

IF YOU COULD THANK GOD IN PERSON FOR ONE THING, WHAT WOULD IT BE?

My wife.

WHAT MAKES COUNTRY MUSIC THE HEART AND SOUL OF AMERICA?

What the song says means everything—what the lyrics say, the words. There are things that have been experienced by many, many, many people in those songs.

DESCRIBE YOUR ULTIMATE MUSICAL PERFORMANCE.

My ultimate musical performance would be if there were not one moment of self-consciousness and I felt the liberation that I get in little parcels sometimes, but if I felt that through the whole concert, that would be the ultimate.

HAVE YOU EVER HEARD A SONG YOU WISH THAT YOU HAD WRITTEN?

I wish I had written "Like a Rolling Stone." I wish I had written "Yesterday." "Hey Porter." "What the World Needs Now Is Love."

WAS THERE A MOMENT WHEN YOU KNEW YOU HAD TO BE A COUNTRY MUSICIAN?

There was a defining moment when I knew I had to be a songwriter. It was when I wrote the first song that was a pretty good song, not the first one I wrote ever, but this flood of passion went through me for the discipline of songwriting. It was the moment that sealed the deal for me. As far as being a performing musician, I was deep into it all before I felt a profound connection.

DO YOU HAVE ANY SPECIAL THING YOU DO BEFORE YOU PERFORM?

Yes, but it's secret.

IF YOU WEREN'T A SINGER, WHAT WOULD YOU HAVE BEEN?

An artist, performer, or writer in another world. I would have written novels and painted. I can't imagine doing something else. In another life, I would like to do something in my body—dance or something.

IF YOU COULD THANK GOD IN PERSON FOR ONE THING, WHAT WOULD IT BE?

My children.

WHAT MAKES COUNTRY MUSIC THE HEART AND SOUL OF AMERICA?

Country music has traditionally been about more subject matter than just romantic love . . . there've been deep, dark Appalachian songs about mothers, sadness, babies, death, family, and travel and all those things that are so intrinsic to the American experience.

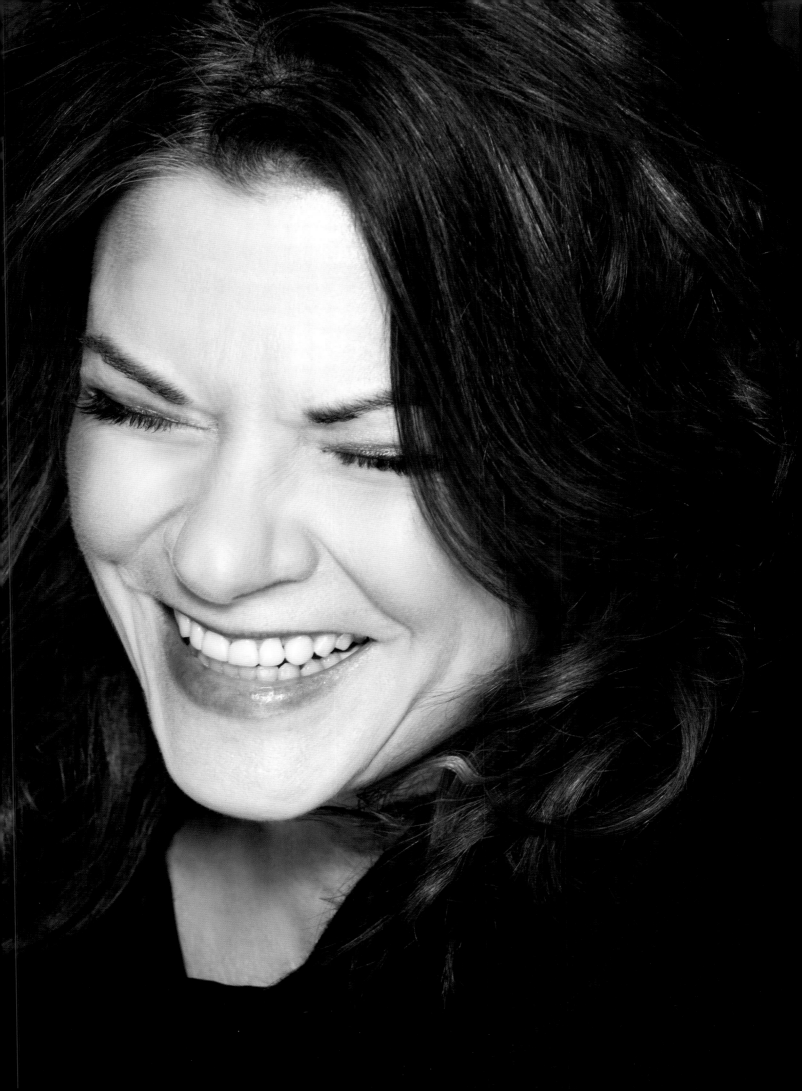

BRAD PAISLEY ♫

DESCRIBE YOUR ULTIMATE MUSICAL PERFORMANCE.
Me and Eric Clapton playing with Ringo Starr on drums and Paul McCartney on bass covering Beatles songs at Shea Stadium.

HAVE YOU EVER HEARD A SONG YOU WISH THAT YOU HAD WRITTEN?
"The Chair," by George Strait, written by Dean Dillon and Hank Cochran. One of the best songs ever. Great song, great story . . . really like no other.

WAS THERE A DEFINING MOMENT WHEN YOU KNEW YOU HAD TO BE A COUNTRY MUSICIAN?
I saw my first tour bus when I was a kid at the Wheeling Jamboree. I saw the musicians pile off in the morning with their coffee, and I thought that had to be the coolest life there is.

DO YOU HAVE ANY SPECIAL THING YOU DO BEFORE YOU PERFORM?
We make French press coffee, which makes us bounce around a little more onstage, make sure that my fly is zipped, and then it's time . . . pretty much as simple as that.

IF YOU WEREN'T A SINGER, WHAT WOULD YOU HAVE BEEN?
Probably a carpenter. The reward of making something is very appealing.

WHAT MAKES COUNTRY MUSIC THE HEART AND SOUL OF AMERICA?
Its ability to tell a story, and therefore its ability to become a very important part of people's lives.

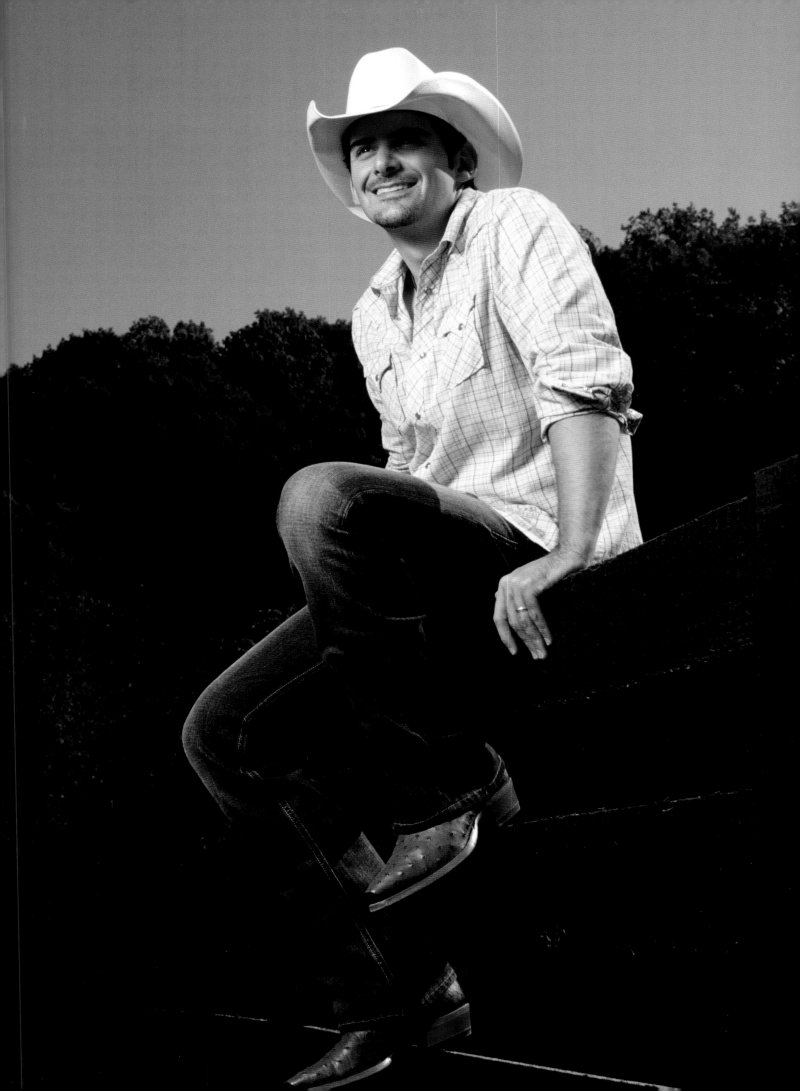

JD SOUTHER

DESCRIBE YOUR ULTIMATE MUSICAL PERFORMANCE.

Past and future included? Maybe it's Coltrane in a small club. Anywhere. Late. Truthfully, there probably couldn't be an ultimate performance for me because I'm always looking to work something out in the next one. I don't mean to make performance sound heavy or like private study because it isn't, but certain things happen only onstage. It's the night, the specific gravity of that moment, something goofy—who knows? Someone plays something they haven't played before and that leads someone else into new territory or maybe playing what you think is precisely what you played the night before is just somehow . . . Music is magic. Great music is sacred. I never take any of it for granted. That question is too difficult.

HAVE YOU EVER HEARD A SONG YOU WISH THAT YOU HAD WRITTEN?

Often, but what comes to mind is "Shelter from the Storm," by Bob Dylan.

WAS THERE A MOMENT WHEN YOU KNEW YOU HAD TO BE A COUNTRY MUSICIAN?

I've been playing music as long as I can remember. I'm a lifer.

DO YOU HAVE ANY SPECIAL THING YOU DO BEFORE YOU PERFORM?

A little warmup is best, a few minutes of privacy and quiet. It's a poor time to get a conversation going. It's a rich time to meditate.

IF YOU WEREN'T A SINGER, WHAT WOULD YOU HAVE BEEN?

A drummer, sax man, poet, something that made sense of the world to me. There was really no plan B. I've always loved racing, too, but I'm pretty sure I took the right road.

IF YOU COULD THANK GOD IN PERSON FOR ONE THING, WHAT WOULD IT BE?

My parents.

WHAT MAKES COUNTRY MUSIC THE HEART AND SOUL OF AMERICA?

The great Duke Ellington once said there are only two kinds of music: good music and bad music. That's the side I'm on. The heart and soul of America is always evolving, a work in progress, and music is an identifiable pulse. The heart and soul of music is heart and soul, and good country music has all you can handle.

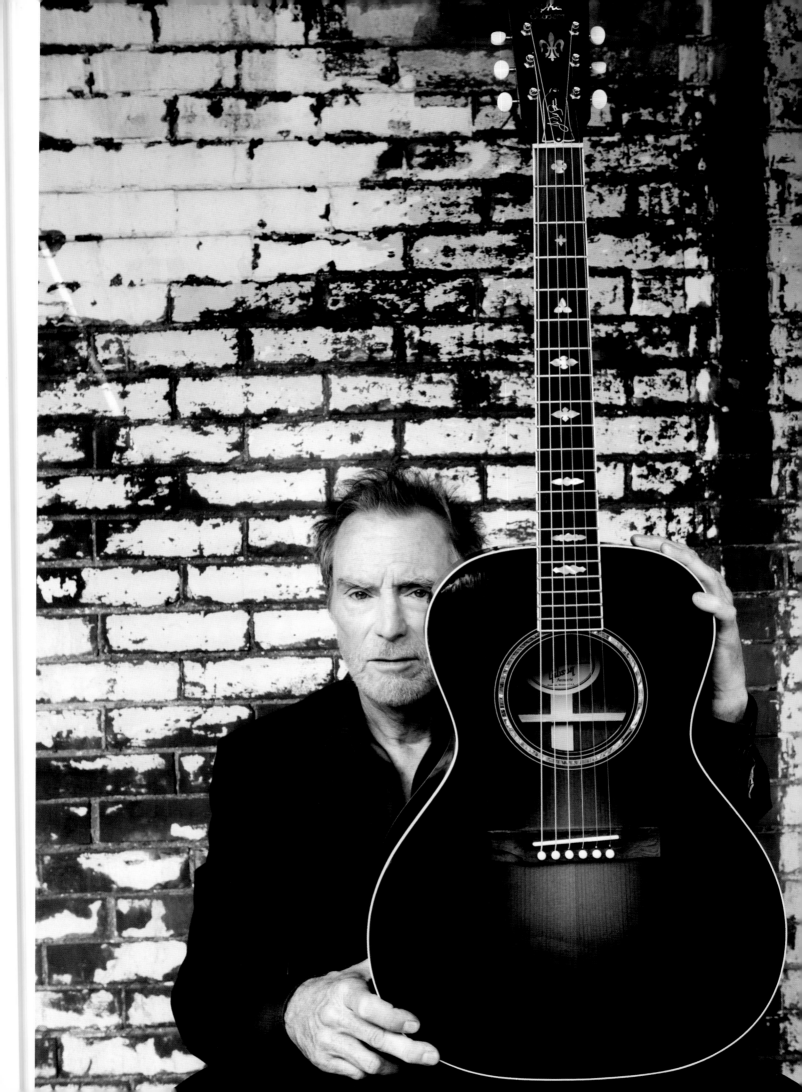

SUGARLAND

Jennifer Nettles

DESCRIBE YOUR ULTIMATE MUSICAL PERFORMANCE.
A dream would be to play Carnegie Hall with a wonderful jazz-inspired band like the Noisemakers or Van Morrison's band.

WAS THERE A MOMENT WHEN YOU KNEW YOU HAD TO BE A COUNTRY MUSICIAN?
From the time I was a little girl, I have always loved music and wanted to create it and perform it. It just so happened that country radio found me first. I love being a musician in general. Any kind. Any flavor. Any time.

IF YOU WEREN'T A SINGER, WHAT WOULD YOU HAVE BEEN?
I would have probably been a human rights activist. At the end of the day, they hold the same intention: to give a voice to the people who can't be heard and to tell their stories.

IF YOU COULD THANK GOD IN PERSON FOR ONE THING, WHAT WOULD IT BE?
Love and a life lived having known it.

WHAT MAKES COUNTRY MUSIC THE HEART AND SOUL OF AMERICA?
We are beautifully flawed creatures. The stories in country music celebrate that. Both the beauty and the flaws.

Kristian Bush

DESCRIBE YOUR ULTIMATE MUSICAL PERFORMANCE.
Probably peforming in Wembley Stadium in London with our band now.

WAS THERE A MOMENT WHEN YOU KNEW YOU HAD TO BE A COUNTRY MUSICIAN?
Maybe when I was born. I was born and raised in Sevierville, Tennessee, hometown of Dolly Parton. Music was a part of life in the mountains.

DO YOU HAVE ANY SPECIAL THING YOU DO BEFORE YOU PERFORM?
We pray at the side of the stage.

IF YOU WEREN'T A SINGER, WHAT WOULD YOU HAVE BEEN?
Something that required dreaming big.

IF YOU COULD THANK GOD IN PERSON FOR ONE THING, WHAT WOULD IT BE?
For my mother.

WHAT MAKES COUNTRY MUSIC THE HEART AND SOUL OF AMERICA?
The stories in country music are the stories of all people no matter where in America you live.

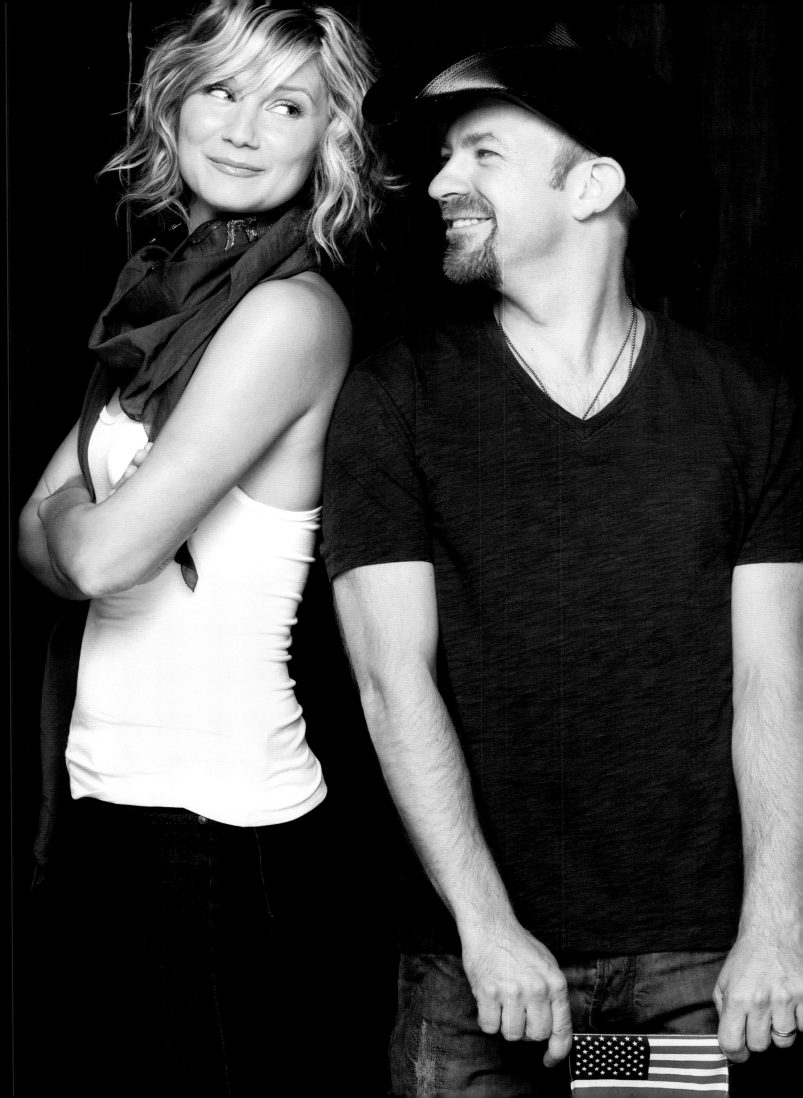

THE OAK RIDGE BOYS

Joe Bonsall

DESCRIBE YOUR ULTIMATE MUSICAL PERFORMANCE.

We have already done it. It was the Jamboree in the Hills, which is the Super Bowl of country music. We have played it more than any other country act. In 1979 and 1980, we played the Full House tour, which was the first big arena concert tour in country music, with Kenny Rogers. I am playing with the people I love to play with every day.

HAVE YOU EVER HEARD A SONG YOU WISH THAT YOU HAD WRITTEN?

Oh, yeah, lots of them. I have so much respect for the songwriters in this town [Nashville], I can't think of a specific song 'cause there are so many out there.

WAS THERE A MOMENT WHEN YOU KNEW YOU HAD TO BE A COUNTRY MUSICIAN?

Since I was a little boy I always knew I wanted to sing. I never really wanted specifically to be a country singer; I just wanted to sing.

DO YOU HAVE ANY SPECIAL THING YOU DO BEFORE YOU PERFORM?

I just roll out there and sing. I will play the banjo for an hour or two before a show. It clears my head.

IF YOU WEREN'T A SINGER, WHAT WOULD YOU HAVE BEEN?

I would be a veterinarian. I worked for a vet for many years and I still love animals.

IF YOU COULD THANK GOD IN PERSON FOR ONE THING, WHAT WOULD IT BE?

I would thank God for my mother. She was an incredible woman, so much so that I wrote a book about her.

WHAT MAKES COUNTRY MUSIC THE HEART AND SOUL OF AMERICA?

It's not just country music. It's songs that talk about life, and country music does that. It's about middle America, and we are the quintessential American music group; we are about family values.

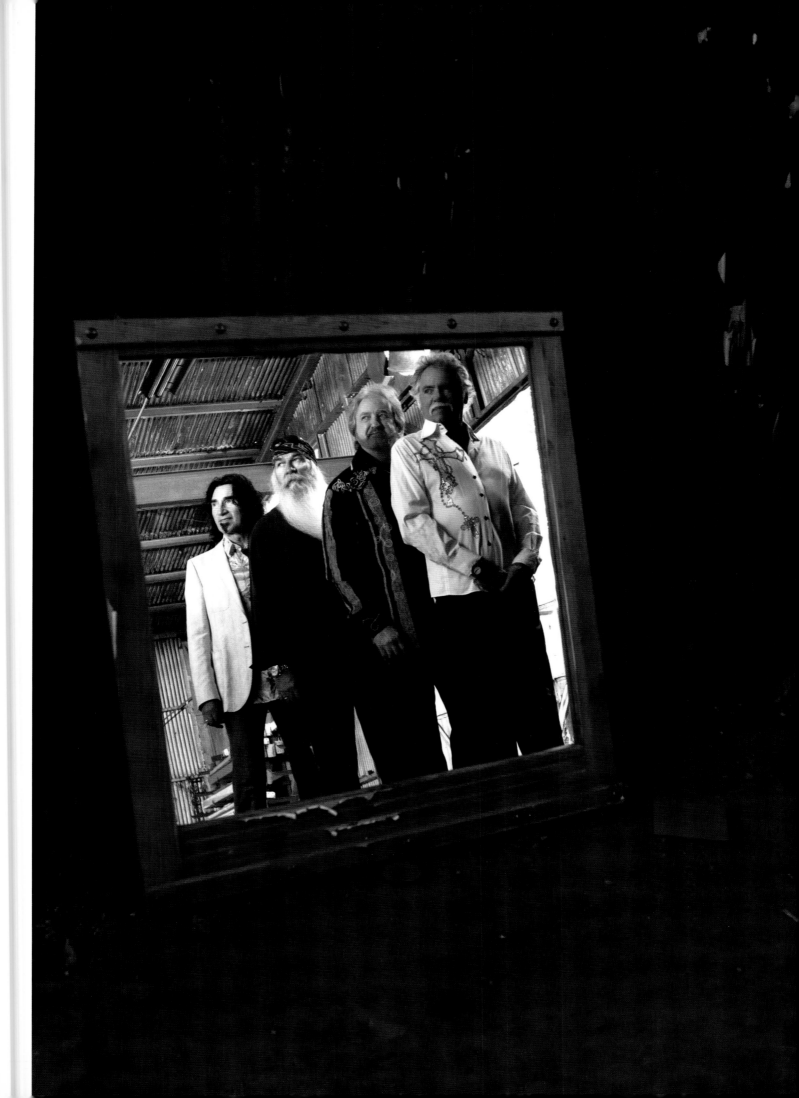

William Lee Golden

DESCRIBE YOUR ULTIMATE MUSICAL PERFORMANCE.
Salt Lake City with the Mormon Tabernacle Choir and Orchestra with the Oak Ridge Boys and the Band.

HAVE YOU EVER HEARD A SONG YOU WISH THAT YOU HAD WRITTEN?
"The Long and Winding Road," by the Beatles.

WAS THERE A MOMENT WHEN YOU KNEW YOU HAD TO BE A COUNTRY MUSICIAN?
I started singing when I was real young. This is something I wanted to do since childhood.

DO YOU HAVE ANY SPECIAL THING YOU DO BEFORE YOU PERFORM?
No, I don't think so . . . [*takes glasses off*] . . . Try to be sober.

IF YOU WEREN'T A SINGER, WHAT WOULD YOU HAVE BEEN?
I picked up painting recently. I love art and museums. Painter.

IF YOU COULD THANK GOD IN PERSON FOR ONE THING, WHAT WOULD IT BE?
For life and for health and for such an amazing journey through life, all the things, people, places, what I've seen, and for my family. And I do thank Him for my many blessings daily, because I feel so blessed in life. And I thank God for my wife, sons, and grandkids. Fatherhood is a wonderful experience.

WHAT MAKES COUNTRY MUSIC THE HEART AND SOUL OF AMERICA?
I grew up on a cotton and peanut farm in southern Alabama. It was a family farm. We lived close to the land, our friends, neighbors, things happening in our community. Being in touch with God and nature. Songs about love and life—that's something we carry with us, our foundation, the heritage, of where we came from. The love of our life and love sometimes is not permanent; it can be a fleeting thing. It's like that saying, "It's better to have loved and lost than never to have loved at all." I feel loved and blessed that I have a beautiful and loving wife, and I know I'm not special, and she makes me special.

Richard Sterban

DESCRIBE YOUR ULTIMATE MUSICAL PERFORMANCE.
Personally, I would like to be on a Caribbean island having a casual music performance with not that many people.

HAVE YOU EVER HEARD A SONG YOU WISH THAT YOU HAD WRITTEN?
The song "Zion Gate," by Quito Rymer, from Tortola [in the British Virgin Islands], who is the coolest gospel singer.

WAS THERE A MOMENT WHEN YOU KNEW YOU HAD TO BE A COUNTRY MUSICIAN?
The first time I sang soprano, I was 6 years old. I sang the solo in Sunday school. I remember that day. I felt that was what I was meant to do, be in front of people and use my God-given talent.

DO YOU HAVE ANY SPECIAL THING YOU DO BEFORE YOU PERFORM?
I like to be alone on the bus and be quiet, because talking is hard on the voice.

IF YOU WEREN'T A SINGER, WHAT WOULD YOU HAVE BEEN?
I would like to have been a baseball player or somehow involved in baseball.

IF YOU COULD THANK GOD IN PERSON FOR ONE THING, WHAT WOULD IT BE?
Allowing me to meet my wife.

WHAT MAKES COUNTRY MUSIC THE HEART AND SOUL OF AMERICA?
It's music of the people, which talks about real-life situations that most people can identify with.

Duane Allen

DESCRIBE YOUR ULTIMATE MUSICAL PERFORMANCE.
My ultimate performance was at a children's hospital in St. Louis with the other Oak Ridge Boys. The patient I remember most could only move his eyelids. The nurses told us that if he moved his eyelids, it would mean he liked what we were doing. When we sang "Elvira," his eyelids were going so fast they looked like butterflies.

HAVE YOU EVER HEARD A SONG YOU WISH THAT YOU HAD WRITTEN?
"He Stopped Loving Her Today."

WAS THERE A MOMENT WHEN YOU KNEW YOU HAD TO BE A COUNTRY MUSICIAN?
Yes. We opened a show for Freddie Fender in Arizona, and the crowd went wild when they heard Richard Sterban hit one of his unbelievably low notes. We got off stage and realized that all we needed to get to this crowd was some great country songs.

DO YOU HAVE ANY SPECIAL THING YOU DO BEFORE YOU PERFORM?
I rise from a nap in a hotel room no later than 4. If we need a sound check or to rehearse a song or two, we do that before 6. Eat with our band and crew and have a great visit with them, and then it's back to the bus. If family or close friends are there, this gives us a short time for a quality visit. Then we get ready for the show and are usually available for a meet-and-greet. I try to say hello to all of our guests before the show, because at the end, I am exhausted and sweaty and just want to cool off and relax.

IF YOU WEREN'T A SINGER, WHAT WOULD YOU HAVE BEEN?
Early on, I would have enjoyed being a DJ or radio station owner. I was a DJ in college and loved it. Since I've been in the business for years, I have had a lot of success in building record studios and starting publishing companies. I loved both of those areas of the business.

IF YOU COULD THANK GOD IN PERSON FOR ONE THING, WHAT WOULD IT BE?
For guiding my career every step of the way and for my continued good health. Also for my family and their love and support. For the fans, who've made our work possible, because they continue to come and see us. I would thank God for Jesus Christ.

WHAT MAKES COUNTRY MUSIC THE HEART AND SOUL OF AMERICA?
Because the subject of almost every country song you hear is the heart and soul of America.

DESCRIBE YOUR ULTIMATE MUSICAL PERFORMANCE.

My ultimate musical performance would be to sing a duet with Tony Bennett at the Grammys with a full orchestra.

HAVE YOU EVER HEARD A SONG YOU WISH THAT YOU HAD WRITTEN?

"Amazing Grace."

WAS THERE A MOMENT WHEN YOU KNEW YOU HAD TO BE A COUNTRY MUSICIAN?

I was a teenager, and my very first country concert was George Jones and Merle Haggard; my first rock concert was the Who, and then I saw Bonnie Raitt. I knew after those collective experiences that I had to follow in their footsteps.

DO YOU HAVE ANY SPECIAL THING YOU DO BEFORE YOU PERFORM?

I spray sparkles in my hair and do my deep breath in and say, "In with peace," and then exhale and say, "Out with fear," before I go onstage.

IF YOU WEREN'T A SINGER, WHAT WOULD YOU HAVE BEEN?

I would have worked with children and animals, or I would've been a farmer.

IF YOU COULD THANK GOD IN PERSON FOR ONE THING, WHAT WOULD IT BE?

Forgiveness and healing my mama from hepatitis C.

WHAT MAKES COUNTRY MUSIC THE HEART AND SOUL OF AMERICA?

Real words for real people in the real world. Country music is the poetry of everyday life.

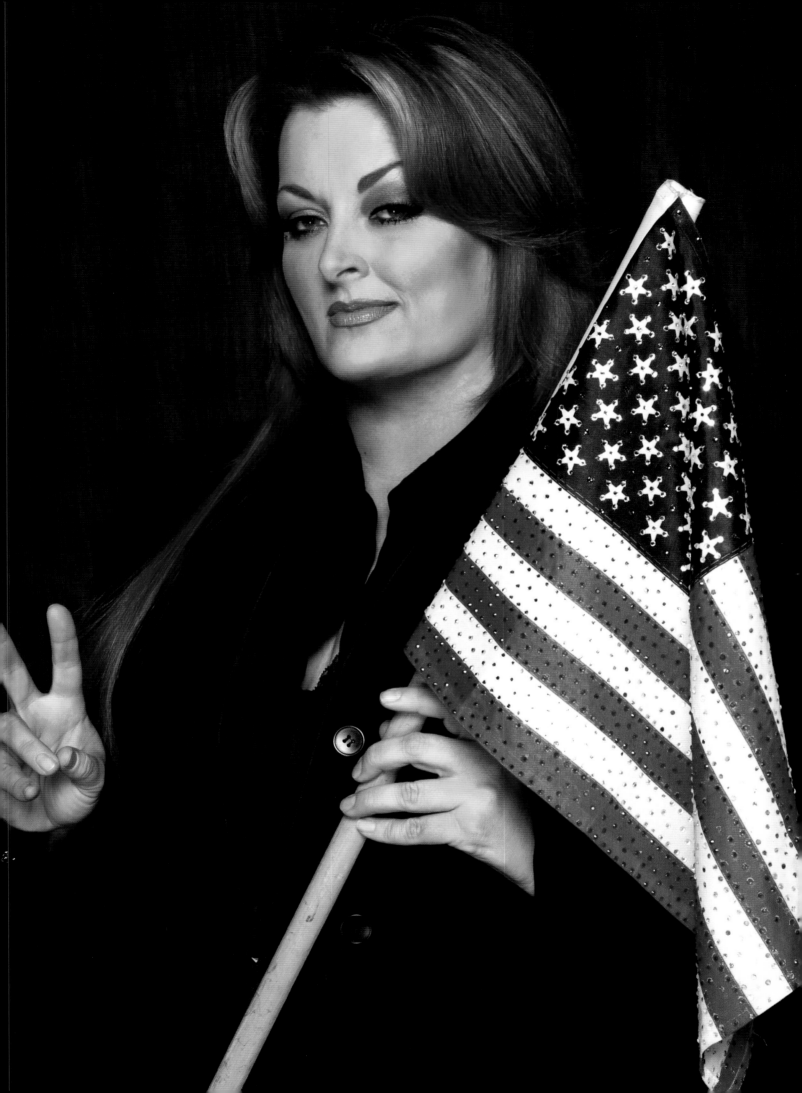

Bill Anderson

DESCRIBE YOUR ULTIMATE MUSICAL PERFORMANCE.

I don't know that I have one singular such place. Somewhere big enough to hold a good-size crowd but small enough to feel as though we were gathered in my living room. Everyone could see and hear every note and every nuance . . . appreciating the good and forgiving the faulty.

HAVE YOU EVER HEARD A SONG YOU WISH THAT YOU HAD WRITTEN?

Many. The one that stands out above all others in my mind is "The Song Remembers When," by Hugh Prestwood.

WAS THERE A MOMENT WHEN YOU KNEW YOU HAD TO BE A COUNTRY MUSICIAN?

Not really. It was something I always wanted to do, but I figured those kinds of careers belonged to people much more talented and much more fortunate than I am.

DO YOU HAVE ANY SPECIAL THING YOU DO BEFORE YOU PERFORM?

I silently pray that God will allow me do the best show I am capable of doing at that particular time and place in my life. And that the things I say and do onstage will reflect positively on Him.

IF YOU WEREN'T A SINGER, WHAT WOULD YOU HAVE BEEN?

I would have been in some form of mass communications—a newspaper or magazine writer, a radio or television announcer.

IF YOU COULD THANK GOD IN PERSON FOR ONE THING, WHAT WOULD IT BE?

I would have to thank Him for two things: my health over the years, and parents who loved me enough to show me the right paths to follow in life but who, at the same time, gave me the freedom to make my own choices.

WHAT MAKES COUNTRY MUSIC THE HEART AND SOUL OF AMERICA?

The type of country music that I love is, for the most part, a music of hope, promise, and a better tomorrow. It's a well the common man and woman can drink and draw strength from, and believe in.

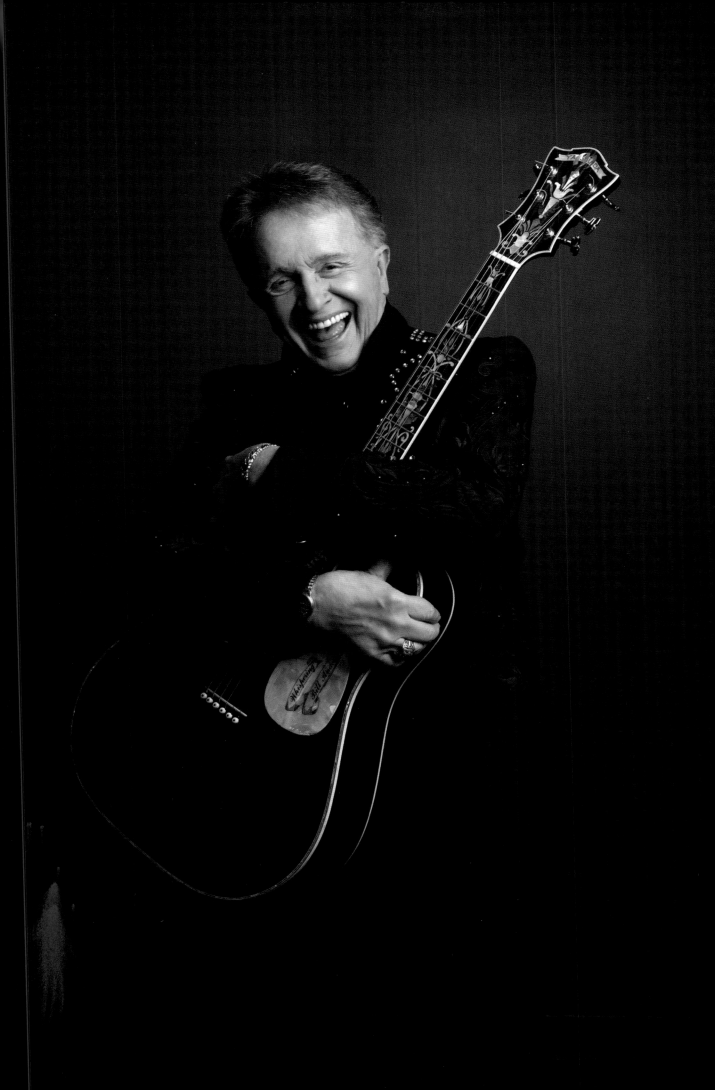

JAKE OWEN

WHAT MAKES COUNTRY MUSIC THE HEART AND SOUL OF AMERICA?

It's called country music because it's about what makes up this country: the fun times, the hard times, and the hard-working people who support it.

DESCRIBE YOUR ULTIMATE MUSICAL PERFORMANCE.

I am not the guy who goes to church every Sunday, but I am devout enough to know I have been given a gift, and the moment I am called to wherever I am called, I will be ready to perform and that will define who I am. That will be my ultimate performance.

HAVE YOU EVER HEARD A SONG YOU WISH THAT YOU HAD WRITTEN?

No . . . but there are a lot of songs I have listened to that made me want to be a fly on the wall in the room while they were written so I could have watched and learned.

WAS THERE A MOMENT WHEN YOU KNEW YOU HAD TO BE A COUNTRY MUSICIAN?

No. Music has always carried me through life, and country music kept bringing me back to who I really am.

DO YOU HAVE ANY SPECIAL THING YOU DO BEFORE YOU PERFORM?

I always drink an entire bottle of water while I walk off the bus to the stage. Right before I go onstage, I always bump fists with my tour manager, who is an icon himself.

IF YOU WEREN'T A SINGER, WHAT WOULD YOU HAVE BEEN?

I would have been anything that helps people in their lives. I think I am doing that now in music.

IF YOU COULD THANK GOD IN PERSON FOR ONE THING, WHAT WOULD IT BE?

Life.

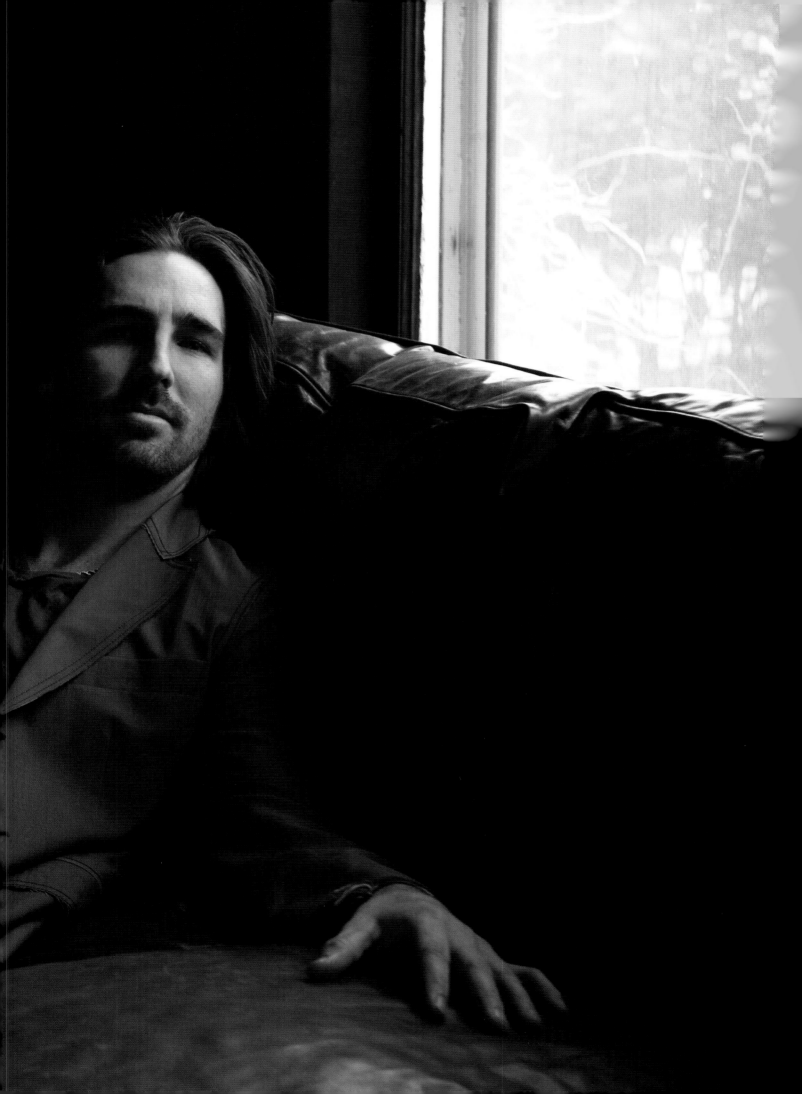

DESCRIBE YOUR ULTIMATE MUSICAL PERFORMANCE.

I would love to do something with Shania Twain and Lionel Richie at the Hollywood Bowl with the LA symphony. I think that would be something I would never forget.

HAVE YOU EVER HEARD A SONG YOU WISH THAT YOU HAD WRITTEN?

I think "Live Like You Were Dying." I like songs that make statements that make you stop and think, and that song touches me in a special way. Maybe it's because of my age—I don't know.

WAS THERE A MOMENT WHEN YOU KNEW YOU HAD TO BE A COUNTRY MUSICIAN?

Yes, in 1976, maybe, I went to Fan Fair in Nashville. I had just come from the First Edition. I walked in and they said something like, "Please welcome Hank Waller . . . he had a hit in 1950," and the place went crazy, and I thought, "This is where I need to be."

DO YOU HAVE ANY SPECIAL THING YOU DO BEFORE YOU PERFORM?

Before I perform the one thing I don't do is eat. I can't eat for a couple of hours before the show. And I drink hot water and lemon and honey, and I rehearse with the band. It's a chance to kind of run new songs and run old songs we haven't done in a while and rehearse and kind of get my throat warmed up rather than do scales—I can't do scales. Scales is like exercising—I don't do either one.

IF YOU WEREN'T A SINGER, WHAT WOULD YOU HAVE BEEN?

In high school, I studied commercial art, and I studied architecture. I was really a pretty decent architectural student . . . as good as you could be in high school, I guess. I knew how to make all the shapes. I always liked that, and even today, one of my thrills in life is design and decorating. I decorate all of my own houses and do all my own landscaping, and I had a design company with a friend of mine for a while. I don't know that I would have been given that opportunity without the success I've had, but I think one of the things I'm really good at is decorating.

IF YOU COULD THANK GOD IN PERSON FOR ONE THING, WHAT WOULD IT BE?

I don't think I can narrow it down to one thing, but I would say, first, my wife, Wanda; second, the kids; and third, my health.

WHAT MAKES COUNTRY MUSIC THE HEART AND SOUL OF AMERICA?

I've always felt that country music was the white man's rhythm and blues . . . you know, they don't use a lot of colloquialisms and a lot of strange phrases to say a simple thing. Basically, if it hurts, they say it hurts. I've had so many people from other countries say they learned to speak English listening to my music and to country music, because they understood what it meant, so they could learn to say that and know what they were saying. I think that's a great gift that music has. The honesty of the music is, I think, what determines its ability to stay around for a while.

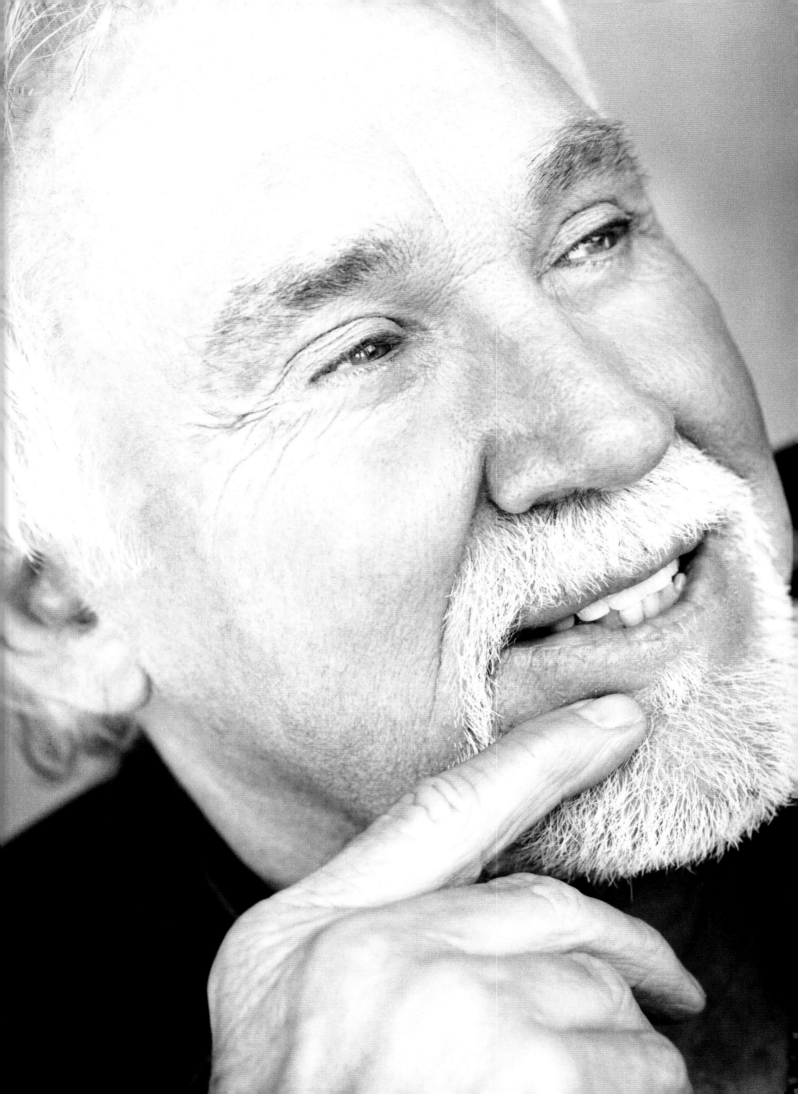

Trisha Yearwood

DESCRIBE YOUR ULTIMATE MUSICAL PERFORMANCE.

Live at Carnegie Hall, just like Judy Garland did it back in the day.

HAVE YOU EVER HEARD A SONG YOU WISH THAT YOU HAD WRITTEN?

Lots of them! "Over the Rainbow." "You Don't Know Me." "The Song Remembers When."

WAS THERE A MOMENT WHEN YOU KNEW YOU HAD TO BE A COUNTRY MUSICIAN?

I knew at 5 years old that I had to be a singer. At the time, it was Cher! Then it became Linda Ronstadt . . . and pretty much still is.

DO YOU HAVE ANY SPECIAL THING YOU DO BEFORE YOU PERFORM?

I never had formal voice lessons, so no vocal warmups or anything, just a powwow with the band to get inspired before we hit the stage.

IF YOU WEREN'T A SINGER, WHAT WOULD YOU HAVE BEEN?

An out-of-work singer.

IF YOU COULD THANK GOD IN PERSON FOR ONE THING, WHAT WOULD IT BE?

Wow. For picking my parents for me. Mostly, for loving me anyway.

WHAT MAKES COUNTRY MUSIC THE HEART AND SOUL OF AMERICA?

I think that country music tells America's story. I think that it's relatable music about life. The song is king in country music.

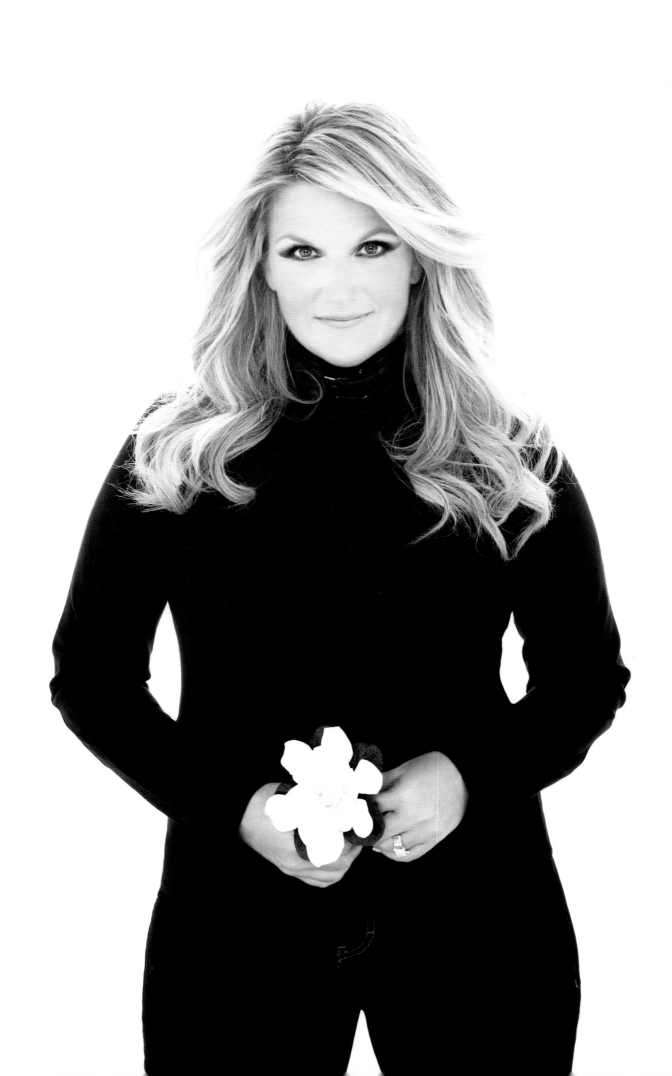

Glen Campbell

DESCRIBE YOUR ULTIMATE MUSICAL PERFORMANCE.

My big kick: I love to play with symphonies. When you've got strings and horns. I would set up like a horseshoe. All that incredible sound with a rhythm section is fantastic. I'd take them to the Grand Canyon and play there in the basin near the Colorado River.

HAVE YOU EVER HEARD A SONG YOU WISH THAT YOU HAD WRITTEN?

The national anthem, but that's already been taken care of.

WAS THERE A MOMENT WHEN YOU KNEW YOU HAD TO BE A COUNTRY MUSICIAN?

No, I just wanted to be a performer.

DO YOU HAVE ANY SPECIAL THING YOU DO BEFORE YOU PERFORM?

Not a thing. I used to be nervous, but not anymore.

IF YOU WEREN'T A SINGER, WHAT WOULD YOU HAVE BEEN?

A golfer.

IF YOU COULD THANK GOD IN PERSON FOR ONE THING, WHAT WOULD IT BE?

The gift He has given me in life. I am very thankful for my wife. What a helping hand she has been. I didn't pick them very well before.

WHAT MAKES COUNTRY MUSIC THE HEART AND SOUL OF AMERICA?

'Cause it came out of the hills.

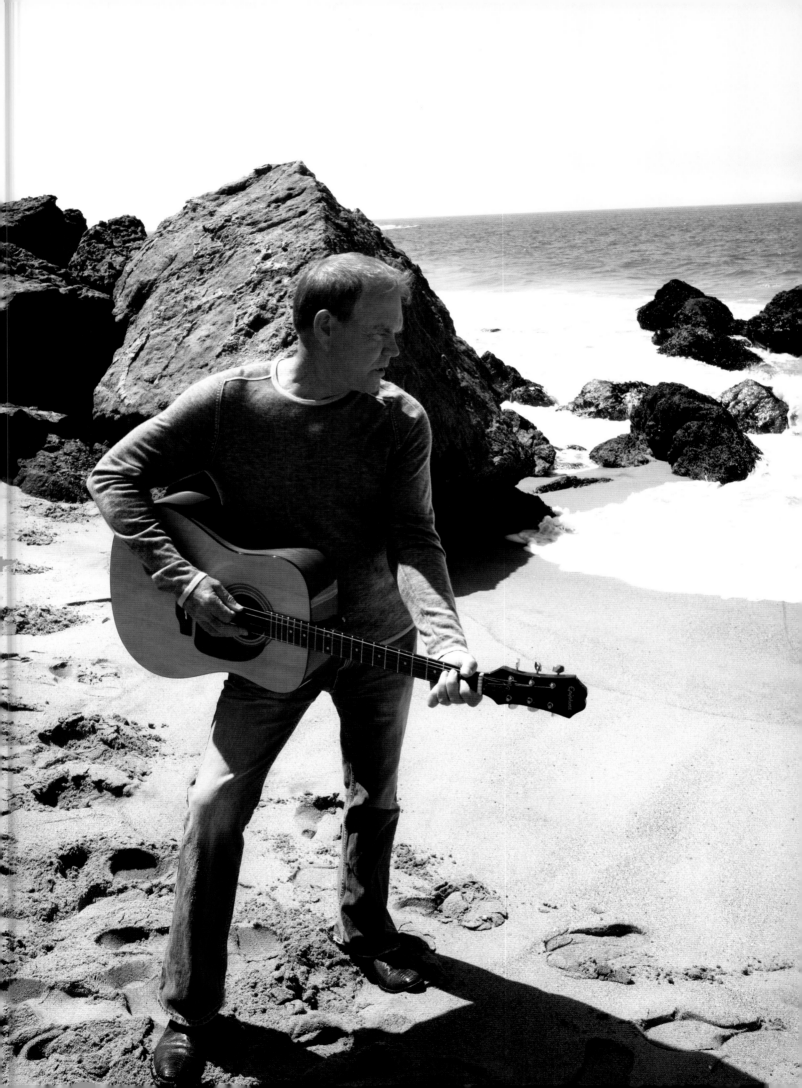

TAYLOR SWIFT

DESCRIBE YOUR ULTIMATE MUSICAL PERFORMANCE.

It would incorporate all of my favorite elements: costume changes, glitter, acoustic elements, and the unexpected.

HAVE YOU EVER HEARD A SONG YOU WISH THAT YOU HAD WRITTEN?

"The Good Stuff," by Kenny Chesney.

WAS THERE A MOMENT WHEN YOU KNEW YOU HAD TO BE A COUNTRY MUSICIAN?

The first time I saw Faith Hill on TV in her video for "This Kiss." I was about 9 years old. The way that I felt, watching her on brightly colored flowers singing a song I couldn't get out of my head, I knew.

DO YOU HAVE ANY SPECIAL THING YOU DO BEFORE YOU PERFORM?

Well, for this tour we are all dressed in band uniforms and giant plumed helmets, and we stand in a circle and put one foot in the middle, and each person gets to give a speech. The person who gives the speech the night before gets to pick the next person, like we are getting ready to go march in a band performance. We act and look like a high school football team. We all say, "Let's go out there and be fearless."

IF YOU WEREN'T A SINGER, WHAT WOULD YOU HAVE BEEN?

Something that has to do with a lot of organization . . . I would be in advertising because you are organizing and creating at the same time.

IF YOU COULD THANK GOD IN PERSON FOR ONE THING, WHAT WOULD IT BE?

For putting ideas in my head that I turn into songs. A lot of times I come up with a song, and I don't know how it comes to me; it just happens. God helps me filter the ideas into a 3½ minute song. My best songs were written in less than 15 minutes. I wrote "Love Story" about a guy I never even kissed in 25 minutes on my bedroom floor.

WHAT MAKES COUNTRY MUSIC THE HEART AND SOUL OF AMERICA?

Because it's people singing about their lives. There are a lot of similarities between rap and country. In both types of music, people sing about how proud they are about the way they live their lives and where they come from.

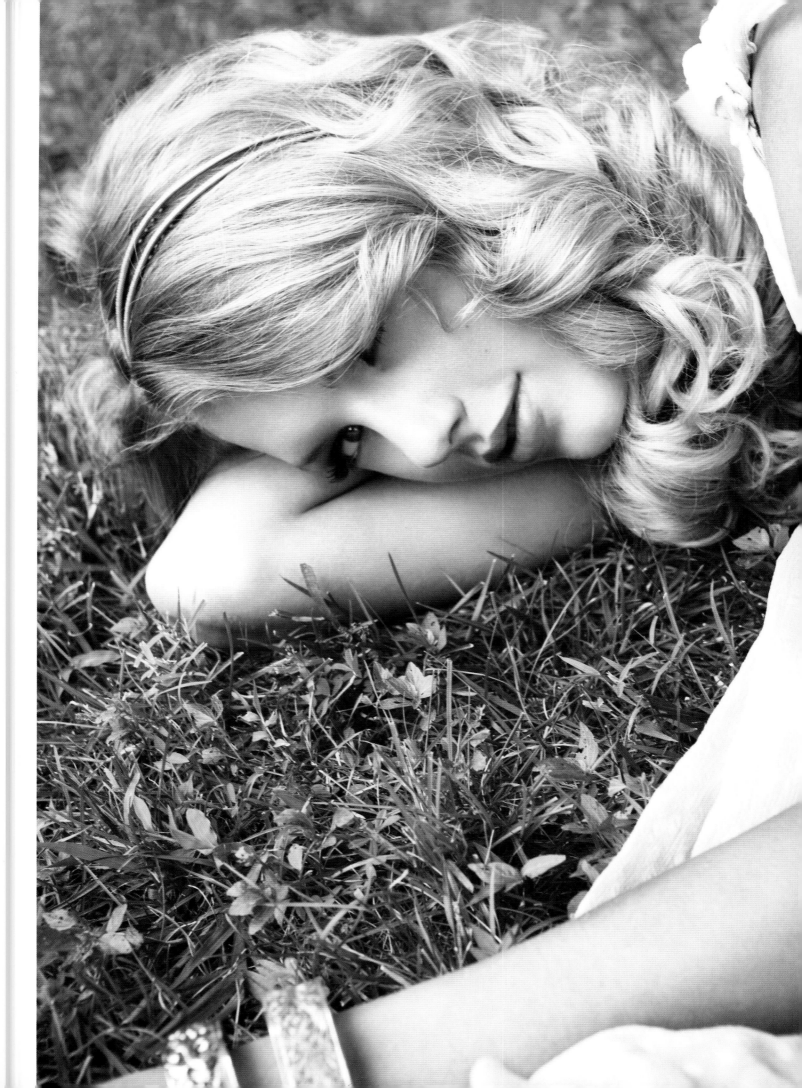

★ DARIUS RUCKER

DESCRIBE YOUR ULTIMATE MUSICAL PERFORMANCE.

I would have a show where I opened up, then Al Green would play, followed by Radney Foster, and R.E.M. would close. Then I could go ahead and die.

HAVE YOU EVER HEARD A SONG YOU WISH THAT YOU HAD WRITTEN?

Lots of them . . . "In Color," by Jamey Johnson . . . the first time I heard the Trace Adkins's recording of the song, I thought it was amazing.

WAS THERE A MOMENT WHEN YOU KNEW YOU HAD TO BE A COUNTRY MUSICIAN?

I knew I wanted to be a country musician when I heard *Del Rio, Texas, 1959*, by Radney Foster. I knew then I wanted to make a country record that affected other people the way that album affected me.

DO YOU HAVE ANY SPECIAL THING YOU DO BEFORE YOU PERFORM?

The band all gets together have a nice toast make sure we are a band before we walk out there to perform.

IF YOU WEREN'T A SINGER, WHAT WOULD YOU HAVE BEEN?

I would have liked to have been a sportscaster, but I probably would have ended up a bartender.

IF YOU COULD THANK GOD IN PERSON FOR ONE THING, WHAT WOULD IT BE?

I thank God for letting me live in the time I live. If I were to go right now, the first thing I would say to Him is thank you.

WHAT MAKES COUNTRY MUSIC THE HEART AND SOUL OF AMERICA?

The lyrics . . . to have a country hit, you have to write a song that affects people and moves people. They are songs that touch people.

DESCRIBE YOUR ULTIMATE MUSICAL PERFORMANCE.

I guess at this point in my career, the ultimate would be traveling back in time to my very first concert experience. I was 6 years old, and my dad took me to the Pollyanna Drive-In Theater in Pikeville, Kentucky, where Lester Flatt and Earl Scruggs played on top of the concession stand. That moment influenced me for life. Another dream would involve being a guest artist on *American Bandstand* accompanied by a band called the Beatles.

HAVE YOU EVER HEARD A SONG YOU WISH THAT YOU HAD WRITTEN?

Too many to list. The one that sticks in my mind is "I Will Always Love You."

WAS THERE A MOMENT WHEN YOU KNEW YOU HAD TO BE A COUNTRY MUSICIAN?

My family had gone to visit my brother at Fort Knox, Kentucky. There was a band playing in the barracks, and my sister, Dottie, got up to sing with them. I knew at that moment I wanted to be a singer.

DO YOU HAVE ANY SPECIAL THING YOU DO BEFORE YOU PERFORM?

I like to have at least two hours to myself before going onstage. Sometimes I may listen to music and hum along or just take that time to focus. And I say a silent prayer before I hit the stage.

IF YOU WEREN'T A SINGER, WHAT WOULD YOU HAVE BEEN?

I think I would have gone into nursing for a career.

IF YOU COULD THANK GOD IN PERSON FOR ONE THING, WHAT WOULD IT BE?

The ability to love.

WHAT MAKES COUNTRY MUSIC THE HEART AND SOUL OF AMERICA?

To me, it's songs about real people in real-life situations.

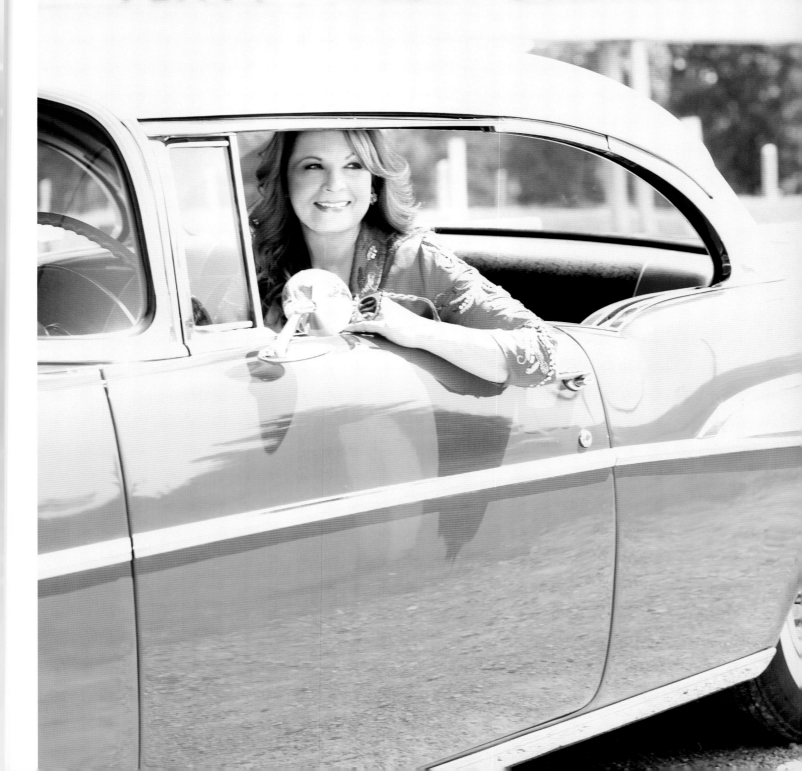

DESCRIBE YOUR ULTIMATE MUSICAL PERFORMANCE.

That's tough. If I could go back in time, probably Elvis, Charlie Daniels, and Chet Atkins sitting on a big front porch, just jamming.

HAVE YOU EVER HEARD A SONG YOU WISH THAT YOU HAD WRITTEN?

Sure. "Live Like You Were Dying" comes to mind. There are so many songs I wish I'd written, it's difficult to pick.

WAS THERE A MOMENT WHEN YOU KNEW YOU HAD TO BE A COUNTRY MUSICIAN?

This is something I dreamed of back in my earliest memories. I think it really hit me when I was a kid listening to Alabama and Charlie Daniels. That was when I asked my folks, "What do I have to do to do what those guys do for a living?"

DO YOU HAVE ANY SPECIAL THING YOU DO BEFORE YOU PERFORM?

I usually try to do vocal warmups and say a little prayer right before walking onstage.

IF YOU WEREN'T A SINGER, WHAT WOULD YOU HAVE BEEN?

I'd like to think I would still be a songwriter. Maybe a carpenter of some sort; I like fixing things around the house. As long as we're dreaming here, maybe a professional fisherman.

IF YOU COULD THANK GOD IN PERSON FOR ONE THING, WHAT WOULD IT BE?

For my family.

WHAT MAKES COUNTRY MUSIC THE HEART AND SOUL OF AMERICA?

You can relate to it, no matter where you're from or how old you are.

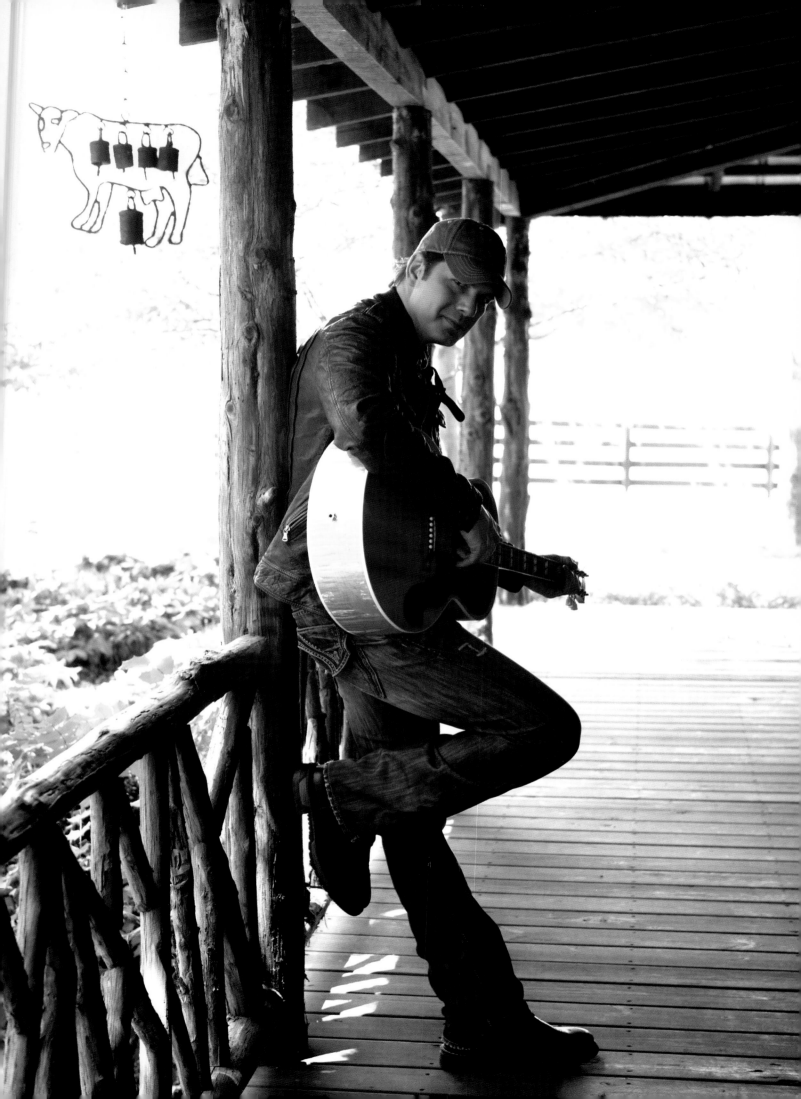

JOE NICHOLS

DESCRIBE YOUR ULTIMATE MUSICAL PERFORMANCE.
I would like to play in a honky-tonk in Texas, 'cause it's familiar surroundings, and Emmylou Harris would join me.

HAVE YOU EVER HEARD A SONG YOU WISH THAT YOU HAD WRITTEN?
"What a Wonderful World," by Louis Armstrong.

WAS THERE A MOMENT WHEN YOU KNEW YOU HAD TO BE A COUNTRY MUSICIAN?
I was at my grandma and grandpa's house when I was little, and my dad was playing, and I thought, "That's what I want to do."

DO YOU HAVE ANY SPECIAL THING YOU DO BEFORE YOU PERFORM?
All hands in, and I pray with the band. I also always eat Lay's potato chips, original flavor. The grease is what's good; it coats my throat. I also sometimes listen to jazz before I perform.

IF YOU WEREN'T A SINGER, WHAT WOULD YOU HAVE BEEN?
A baseball player.

IF YOU COULD THANK GOD IN PERSON FOR ONE THING, WHAT WOULD IT BE?
Jesus.

WHAT MAKES COUNTRY MUSIC THE HEART AND SOUL OF AMERICA?
Country music is real stories that real people tell.

DESCRIBE YOUR ULTIMATE MUSICAL PERFORMANCE.

Grand Ole Opry, Nashville, Tennessee—with my band, the Statesiders. (Done it many times. It is always the ultimate.)

HAVE YOU EVER HEARD A SONG YOU WISH THAT YOU HAD WRITTEN?

Yes! "Wind Beneath My Wings."

WAS THERE A MOMENT WHEN YOU KNEW YOU HAD TO BE A COUNTRY MUSICIAN?

Not as a musician. I'm more of an entertainer and songwriter than a musician. Growing up, I just always felt like I was destined for something.

DO YOU HAVE ANY SPECIAL THING YOU DO BEFORE YOU PERFORM?

Pop the top on a couple of Old Milwaukee Ices.

IF YOU WEREN'T A SINGER, WHAT WOULD YOU HAVE BEEN?

Probably a baker. My dad had a bakery and taught me a lot about baking. I baked while I was in the air force, for 4 years.

IF YOU COULD THANK GOD IN PERSON FOR ONE THING, WHAT WOULD IT BE?

All the blessings He's given me: songs to write, singing voice, ability to entertain, good health, six children, and six grandkids.

WHAT MAKES COUNTRY MUSIC THE HEART AND SOUL OF AMERICA?

The pulse of the people. It's real to life—the good, the bad, and the silly.

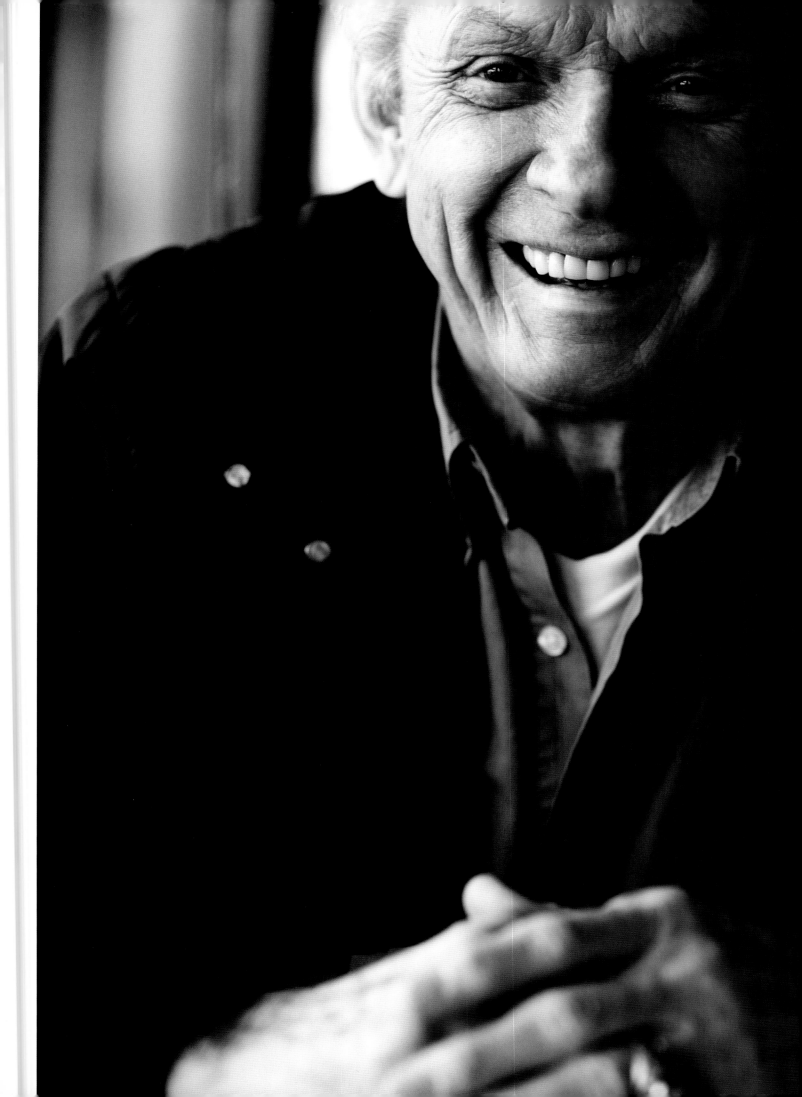

JOSH TURNER

HAVE YOU EVER HEARD A SONG YOU WISH THAT YOU HAD WRITTEN?

A lot of them. One song I heard when I was living in South Carolina working on a tobacco field. I was in my pickup truck and I heard "Out of My Bones," by Randy Travis. It was a different kind of song. It was a renaissance song for Randy Travis and I will never forget hearing it.

DESCRIBE YOUR ULTIMATE MUSICAL PERFORMANCE.

I haven't been around as long as some people in this business, but I have had a lot of my dreams come true so far. One thing I have always dreamed doing an official tour with my heroes. For example, I would like me, Randy Travis, and John Anderson to go on the road and play several dates.

WAS THERE A MOMENT WHEN YOU KNEW YOU HAD TO BE A COUNTRY MUSICIAN?

Once again . . . when I was 13, I sang at my church. I was singing Randy Travis and I got a standing ovation. It was a turning point in my career. It was the first time I had heard an audience giving me real applause. I had heard some amens before, but I thought to myself at that moment, *I could get used to this feeling.*

DO YOU HAVE ANY SPECIAL THING YOU DO BEFORE YOU PERFORM?

Two things: I pray, and I warm up vocally. When I don't get warmed up, it takes me four or five songs to warm up during the show.

IF YOU WEREN'T A SINGER, WHAT WOULD YOU HAVE BEEN?

Other than homeless? Something related to being outside. Farming, soil conservation, or working the land. To be honest, I never had a plan B.

IF YOU COULD THANK GOD IN PERSON FOR ONE THING, WHAT WOULD IT BE?

I thank Him every day for a lot of things. I am assuming you're asking about when I get to Heaven. I would thank Him for being faithful to me and never giving up on me. There was one condition early on in order for me to catch my dreams and that was to trust Him. As long as I trusted Him and put things in His hands, He has blessed me and gotten me through tough times.

WHAT MAKES COUNTRY MUSIC THE HEART AND SOUL OF AMERICA?

Country music has always been the type of music that speaks to the working people. These are people who fight and work for their families. That is what the stories are about and where the music comes from. The music has been changing since the '20s. It sounds different, but at the heart, you will find the stories and inspirations that come from blue-collar and working-class people who don't compromise their beliefs.

DESCRIBE YOUR ULTIMATE MUSICAL PERFORMANCE.

It's so hard because I relate people with the performance; it's the people that make you feel really good. The performance could be anywhere. But the one place—and I played it years ago—is Red Rocks. It's a magical place. It's just so beautiful.

HAVE YOU EVER HEARD A SONG YOU WISH THAT YOU HAD WRITTEN?

Oh, so many. When I started out in the business, I would get all these great songs from so many great writers instead of recording my own songs. *The Tonight Show* theme song [*joking*]. "Wayfaring Stranger"—I find myself singing that song so often.

WAS THERE A MOMENT WHEN YOU KNEW YOU HAD TO BE A COUNTRY MUSICIAN?

I grew up knowing I was going to be a singer. Music was a way of life and a way of entertaining ourselves. We didn't have video games or anything like that. My mom says I could sing before I could walk. I was a very shy child. It's a miracle I could get out on the stage and perform.

DO YOU HAVE ANY SPECIAL THING YOU DO BEFORE YOU PERFORM?

I definitely have to have alone time before I go on. I just need a little time to put my head in the right place and do some breathing exercises.

IF YOU WEREN'T A SINGER, WHAT WOULD YOU HAVE BEEN?

I wanted to be an archaeologist—digging in the dirt—or an FBI agent out in the field.

IF YOU COULD THANK GOD IN PERSON FOR ONE THING, WHAT WOULD IT BE?

I would thank Him for my wonderful family, my great parents, my health. The wonderful life I've had and am still having. He is just awesome.

WHAT MAKES COUNTRY MUSIC THE HEART AND SOUL OF AMERICA?

It's honest. But I think what makes country music what it is, is that it grabs you. There's a lot of heart and soul in it. Especially in the past, it was like a big family. It's losing a little bit of that now.

LITTLE BIG TOWN

Kimberly Schlapman

DESCRIBE YOUR ULTIMATE MUSICAL PERFORMANCE.

We have always wanted to play Red Rocks in Colorado. What a dream location! The four of us have so many musical favorites that it would be difficult to choose one. We've been so fortunate to play with some of our greatest influences, but there are many others we would give our right arms to play with—Dolly Parton and Kris Kristofferson, just to name a couple.

HAVE YOU EVER HEARD A SONG YOU WISH THAT YOU HAD WRITTEN?

I wish we had written "Bring It On Home," from our CD *The Road to Here*. It was written by our producer, Wayne Kirkpatrick, along with Greg Bieck and Tyler Hayes Bieck. When Wayne first played that song for us, we fell in love with it and threatened him within an inch of his life that he'd better not give it to anyone else! He did indeed save it for us, and it became our first top-five hit song.

WAS THERE A MOMENT WHEN YOU KNEW YOU HAD TO BE A COUNTRY MUSICIAN?

Our four households were full of all kinds of music, but country was the definite recurring theme for us all. When we came together as a band, there was no other option for us. Country music is where the true, honest heart of the song and harmony were born, and it's home for us.

DO YOU HAVE ANY SPECIAL THING YOU DO BEFORE YOU PERFORM?

We have a tradition we call hands. We can't do a show without it! We come together with our band guys and gather in a circle a few minutes before showtime. We place our hands on top of each other's. Someone in the circle says a prayer for the show—someone different every night—and after the amens, we all holler out phrases from our favorite Will Ferrell movies. That part sounds crazy and chaotic, I know, and it is, but we love it and it works for us. We're addicted to that moment.

IF YOU WEREN'T A SINGER, WHAT WOULD YOU HAVE BEEN?

A baker or, more specifically, the owner of a coffee shop on a river in a quaint mountain town—where I would bake goodies, of course.

IF YOU COULD THANK GOD IN PERSON FOR ONE THING, WHAT WOULD IT BE?

Second chances and restoration.

WHAT MAKES COUNTRY MUSIC THE HEART AND SOUL OF AMERICA?

Country music is the story of the common man. It tells true stories inspired by the lives of people who experience daily struggles and sweet personal victories.

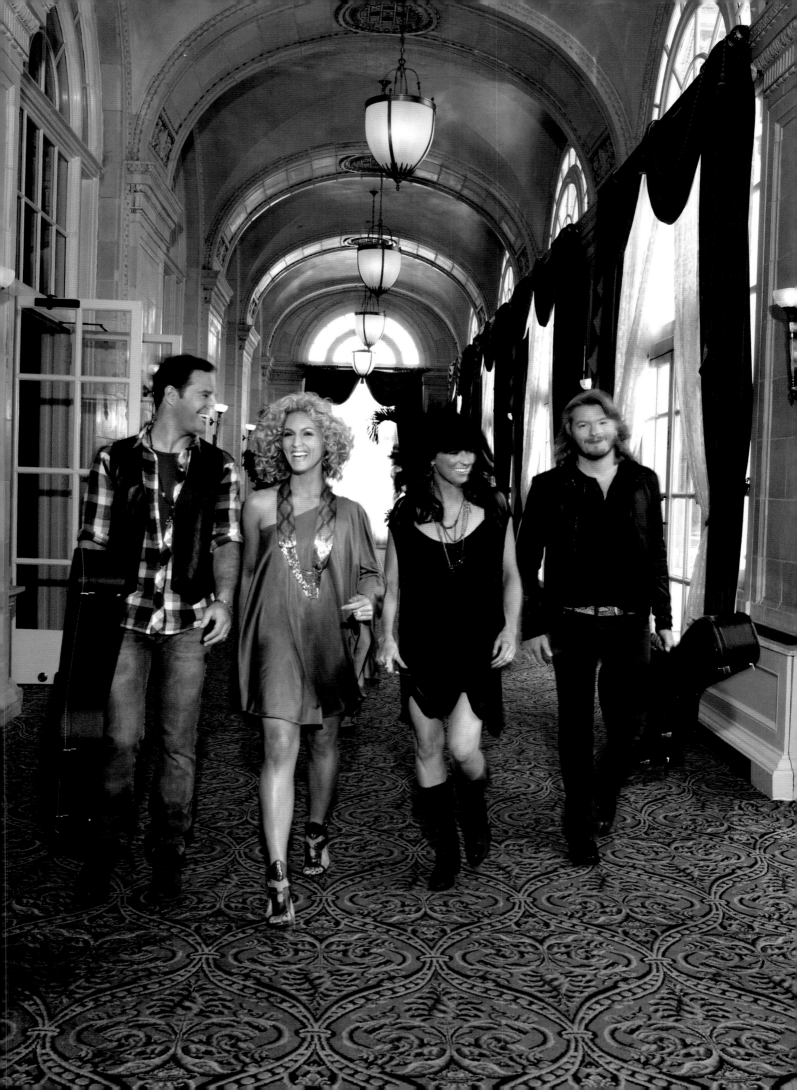

Karen Fairchild

DESCRIBE YOUR ULTIMATE MUSICAL PERFORMANCE.

We have always wanted to play Red Rocks, and I want to see the band sell out Madison Square Garden. That would be unbelievable.

HAVE YOU EVER HEARD A SONG YOU WISH THAT YOU HAD WRITTEN?

I wouldn't even know where to start. Maybe "The Rising," or "Flesh and Blood," or "Jolene."

WAS THERE A MOMENT WHEN YOU KNEW YOU HAD TO BE A COUNTRY MUSICIAN?

I grew up listening to country music and gospel . . . both have been huge influences for me. I remember watching Dolly Parton, Barbara Mandrell, and Loretta Lynn on TV and thinking, what would that be like—to sing and do what you love for a living? I didn't know I would be so blessed to be able to do that myself.

DO YOU HAVE ANY SPECIAL THING YOU DO BEFORE YOU PERFORM?

We get together for "hands," which is a moment of prayer where everyone puts there hands in the middle, and then we irreverently shout out crazy lines from movies we have obsessively watched on the bus. I don't know how it started, but it has never stopped. It makes for the right spirit to take the stage.

IF YOU WEREN'T A SINGER, WHAT WOULD YOU HAVE BEEN?

Probably a kindergarten teacher.

IF YOU COULD THANK GOD IN PERSON FOR ONE THING, WHAT WOULD IT BE?

Family and grace.

WHAT MAKES COUNTRY MUSIC THE HEART AND SOUL OF AMERICA?

This is the art form where you hear real stories being told that are about real people's lives. It is American music.

Jimi Westbrook

DESCRIBE YOUR ULTIMATE MUSICAL PERFORMANCE.

We have always dreamed of playing at Red Rocks. It would be great to play there with the guys who play in our band every night. Most of them have been with us for a long time. It's fun to share those moments with people who you are close to.

HAVE YOU EVER HEARD A SONG YOU WISH THAT YOU HAD WRITTEN?

Yes, many of them. "Blue Eyes Crying in the Rain" is one that comes to mind.

DO YOU HAVE ANY SPECIAL THING YOU DO BEFORE YOU PERFORM?

We all huddle together and say a prayer and then burst into silly, random quotes from movies. It's great for levity before we walk onto the stage.

IF YOU WEREN'T A SINGER, WHAT WOULD YOU HAVE BEEN?

I always loved the medical field.

IF YOU COULD THANK GOD IN PERSON FOR ONE THING, WHAT WOULD IT BE?

My family and the way I was raised.

WHAT MAKES COUNTRY MUSIC THE HEART AND SOUL OF AMERICA?

Country music is about the things that make this country great: family, faith, love, living free, and being proud of who you are and where you came from.

Phillip Sweet

DESCRIBE YOUR ULTIMATE MUSICAL PERFORMANCE.

I would love to perform at Red Rocks in Colorado, with our touring musicians, Greg Hagan, Steve Dale, Steve Sinatra, and Wayne Kirkpatrick, our co-producer and collaborator.

HAVE YOU EVER HEARD A SONG YOU WISH THAT YOU HAD WRITTEN?

"Pride (In the Name of Love)," by U2.

WAS THERE A MOMENT WHEN YOU KNEW YOU HAD TO BE A COUNTRY MUSICIAN?

When I was 15, I heard Steve Wariner's "Small Town Girl," and I was hooked. I knew that country music told the stories that I wanted to tell—pure values, simple pleasures, and real life.

DO YOU HAVE ANY SPECIAL THING YOU DO BEFORE YOU PERFORM?

We always come together before we go onstage, and put our hands together, get focused, and say a prayer. It helps us keep the mood light, and remember why we do this every night.

IF YOU WEREN'T A SINGER, WHAT WOULD YOU HAVE BEEN?

I would say I've always been interested in the healing arts, but playing music is really all I've ever dreamed about doing.

IF YOU COULD THANK GOD IN PERSON FOR ONE THING, WHAT WOULD IT BE?

I would thank God for bringing my daughter, Penelopi, into our lives. I could have never dreamed of someone so beautiful, and the love I would feel for her and my wife.

WHAT MAKES COUNTRY MUSIC THE HEART AND SOUL OF AMERICA?

Country music represents real stories, and real life, and we get to hear a lot of those stories through the people that we meet in our travels. We share many common hopes and dreams, and we are grateful to be a part of the music that is the soundtrack to their lives. They are the ones who make America the amazing place that it is.

DESCRIBE YOUR ULTIMATE MUSICAL PERFORMANCE.

I love to play the Ryman Auditorium here in Nashville. It is the Mother Church of country music. I would have my band that has been with me for years. They know exactly what I want when we are performing a live show.

HAVE YOU EVER HEARD A SONG YOU WISH THAT YOU HAD WRITTEN?

I wish I had written "He Stopped Loving Her Today." It was my biggest hit and my favorite song of all time.

WAS THERE A MOMENT WHEN YOU KNEW YOU HAD TO BE A COUNTRY MUSICIAN?

When I heard Hank Williams on the radio.

DO YOU HAVE ANY SPECIAL THING YOU DO BEFORE YOU PERFORM?

No, not really, but I must admit, I still get a little nervous before every performance.

IF YOU WEREN'T A SINGER, WHAT WOULD YOU HAVE BEEN?

I would have been a painter, I guess. That is what I was doing before I was a singer.

IF YOU COULD THANK GOD IN PERSON FOR ONE THING, WHAT WOULD IT BE?

Sparing my life when I had that bad wreck.

WHAT MAKES COUNTRY MUSIC THE HEART AND SOUL OF AMERICA?

Country music speaks to the heart of people. It tells a story that people can relate to and understand. There is no other genre of music that does it as well.

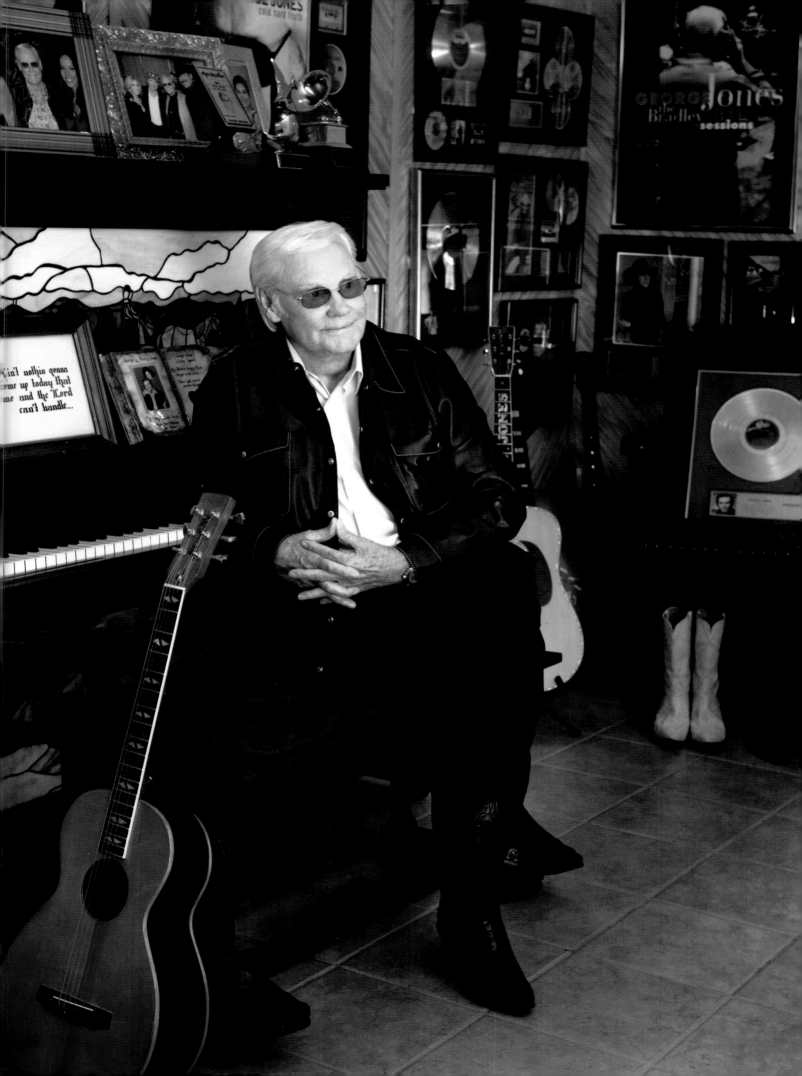

CLINT BLACK

DESCRIBE YOUR ULTIMATE MUSICAL PERFORMANCE.

It would take place in any of the great theaters around the country, but especially in my hometown, Houston. On drums, Levon Helm; on bass guitar, Paul McCartney; on piano, Bruce Hornsby; on guitar—me! On saxophone, Edgar Winter; on steel guitar, Paul Franklin; and on fiddle, Mark O'Connor.

HAVE YOU EVER HEARD A SONG YOU WISH THAT YOU HAD WRITTEN?

"Thanks Again," recorded by Ricky Skaggs.

WAS THERE A MOMENT WHEN YOU KNEW YOU HAD TO BE A COUNTRY MUSICIAN?

I was about 17 when I decided to pursue a music career. At the time, some of the rock 'n' roll on the scene was very country, and it seemed that might be the way to go. That changed in the '80s, and with that, my direction along with it.

DO YOU HAVE ANY SPECIAL THING YOU DO BEFORE YOU PERFORM?

I have a very strict vocal warmup routine that begins early and escalates as the day wears on. About 30 minutes before the show, I start a light vocal warmup and some light stretching. Just before the show begins, the band and I gather for some laughs and last-minute reminders of changes to the set or song arrangements.

IF YOU WEREN'T A SINGER, WHAT WOULD YOU HAVE BEEN?

If I weren't a singer and could've been anything I wanted to be, I would've joined the air force and worked my way into the space program.

IF YOU COULD THANK GOD IN PERSON FOR ONE THING, WHAT WOULD IT BE?

I'd thank God for the life He has given me and the drive to make it count.

WHAT MAKES COUNTRY MUSIC THE HEART AND SOUL OF AMERICA?

In country music, the lyrics are the key to its appeal.

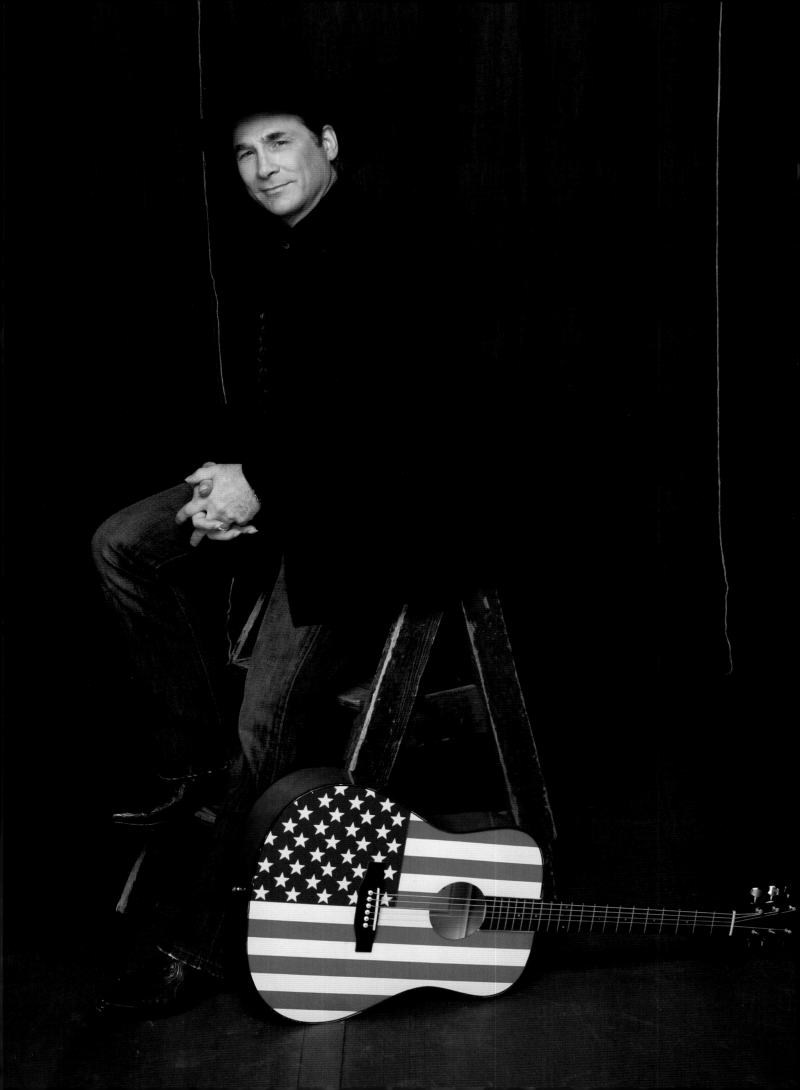

♪ ROY CLARK ♪

DESCRIBE YOUR ULTIMATE MUSICAL PERFORMANCE.

In all the years I have been performing, I have been all around the world—behind the Iron Curtain, Carnegie Hall. When you put them all together, they are all the same. When you think about the venue you're performing in, the audience is the same; it has a heartbeat. Do they want more serious messages? Or more frivolous joking? I let them tell me, and I know within two songs. I would like Little Jimmy Dickens to perform with me.

HAVE YOU EVER HEARD A SONG YOU WISH THAT YOU HAD WRITTEN?

"Yesterday When I Was Young." It really tells you the things that you missed or could have done that you didn't.

WAS THERE A MOMENT WHEN YOU KNEW YOU HAD TO BE A COUNTRY MUSICIAN?

I can't remember when I wasn't involved in music. In the bed lying there in diapers and my dad playing music, I heard it since I heard the human voice. I was destined to play music.

DO YOU HAVE ANY SPECIAL THING YOU DO BEFORE YOU PERFORM?

I say a little prayer to give me strength and communicate with the audience and make them leave feeling better than they did before they came in.

IF YOU WEREN'T A SINGER, WHAT WOULD YOU HAVE BEEN?

A baseball player.

IF YOU COULD THANK GOD IN PERSON FOR ONE THING, WHAT WOULD IT BE?

Boy, so many things. One thing? My health. If you have health, everything else is possible.

WHAT MAKES COUNTRY MUSIC THE HEART AND SOUL OF AMERICA?

Because of the way that it happened. It wasn't planned, it was people working the farm, or factory. In the background, they would start humming and singing lyrics about things they were feeling. It just happened. Hank Williams didn't go to school for music. He went so deep inside lyrically.

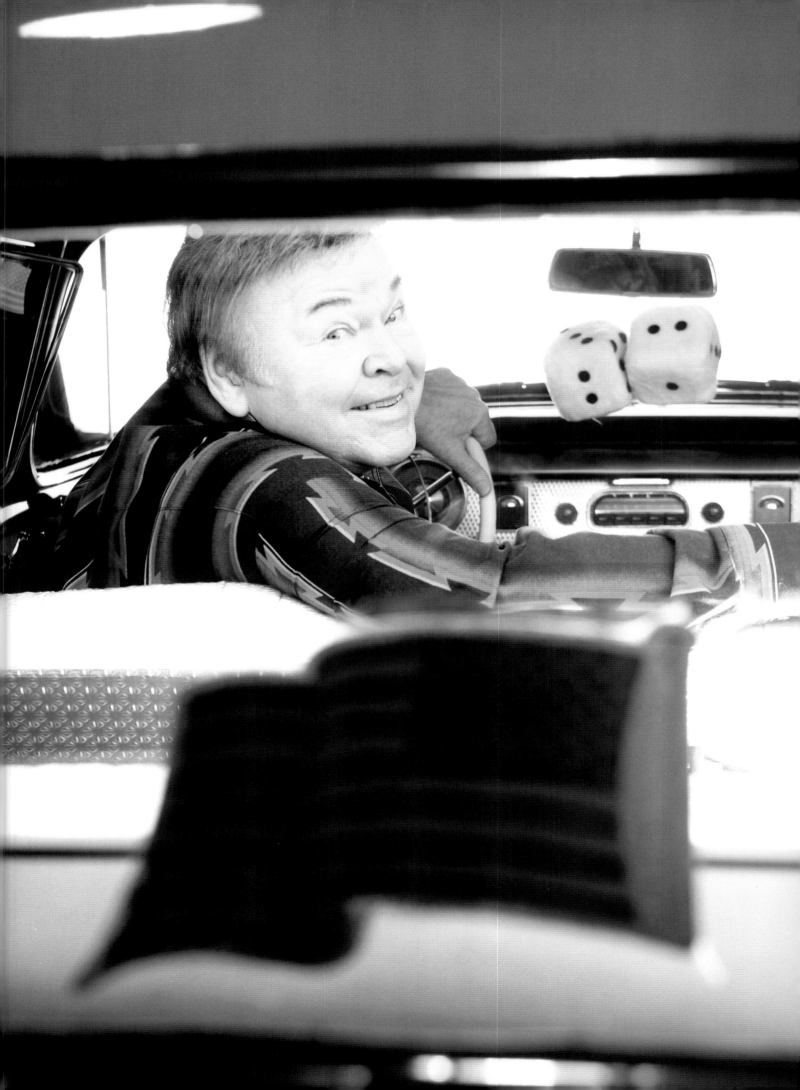

DESCRIBE YOUR ULTIMATE MUSICAL PERFORMANCE.

Wow . . . at this moment what I am craving the most is to have an old-time music jam . . . music, friends and fun. There would be no contracts, record labels, and no one would be politically correct. We would capture that magic that you don't get any more. It would be great to reunite and to have an honest moment onstage.

HAVE YOU EVER HEARD A SONG YOU WISH THAT YOU HAD WRITTEN?

Daily, I hear a song I wish I had written. But to me, "He Stopped Loving Her Today," by George Jones, is the ultimate country song.

WAS THERE A MOMENT WHEN YOU KNEW YOU HAD TO BE A COUNTRY MUSICIAN?

The day I knew I had to be a country artist was the day my baby girl was born, but I wanted to be a country musician since I was 7 years old. I feel like I could have gone into any genre of music, but once I had my daughter I realized no other genre of music is as accepting of the home life and family as country music.

DO YOU HAVE ANY SPECIAL THING YOU DO BEFORE YOU PERFORM?

Fifteen minutes before "go" time, my band and crew gathers together in a circle and we say a prayer and shoot a shot of whiskey.

IF YOU WEREN'T A SINGER, WHAT WOULD YOU HAVE BEEN?

I would have been a bartender, but if I had a different life and a different past, I probably would have gone into forensics.

IF YOU COULD THANK GOD IN PERSON FOR ONE THING, WHAT WOULD IT BE?

My daughter.

WHAT MAKES COUNTRY MUSIC THE HEART AND SOUL OF AMERICA?

Country music is the only honest, truthful, tell-it-like-it-is, no-smoke-and-mirrors music we have.

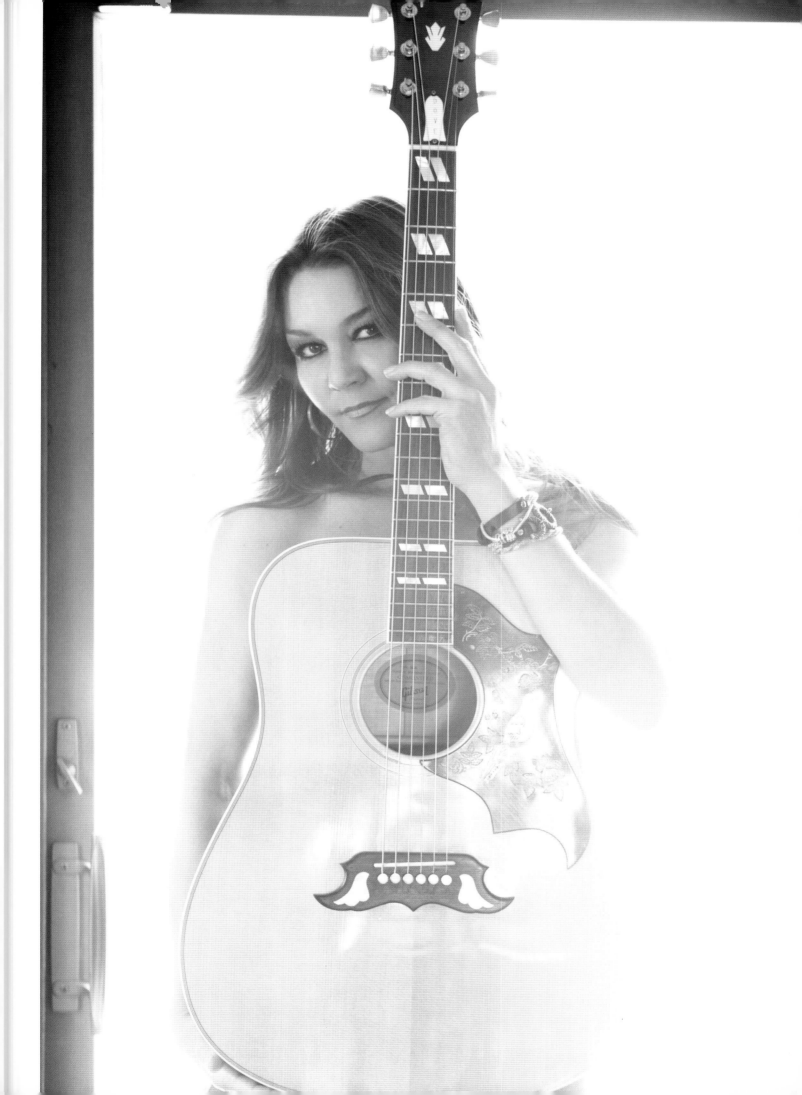

DESCRIBE YOUR ULTIMATE MUSICAL PERFORMANCE.

No doubt it would be a live performance and everyone would be playing at their best. I would want to know that this show touched people in wonderful ways as they listened to songs.

HAVE YOU EVER HEARD A SONG YOU WISH THAT YOU HAD WRITTEN?

I hear those all the time! There are so many that every time you hear them they really strike a chord.

WAS THERE A MOMENT WHEN YOU KNEW YOU HAD TO BE A COUNTRY MUSICIAN?

I don't remember that moment at all. I have been working in front of an audience since I was 9. I just did it because I was told to by my parents. As a teenager I performed because I could make a few dollars. My dad took me to fiddlers' conventions, swing dances, and lots of other places to perform, but I was just doing it 'cause I was told to do. Many years later my wife (and manager) asked me if I would consider making this into a career. I said that I didn't have much else going on, so why not? After all of those years I grew to love performing and love the music.

DO YOU HAVE ANY SPECIAL THING YOU DO BEFORE YOU PERFORM?

No. I show up and hope to remember the words.

IF YOU WEREN'T A SINGER, WHAT WOULD YOU HAVE BEEN?

I loved working on the farm. We still run some calves and horses. Possibly something working on farm and/or ranch.

IF YOU COULD THANK GOD IN PERSON FOR ONE THING, WHAT WOULD IT BE?

Sending his Son to die for my sins, 'cause boy, I have had a bunch of them. And for forgiveness—that is so important to me.

WHAT MAKES COUNTRY MUSIC THE HEART AND SOUL OF AMERICA?

It is because the music itself speaks to people about what they live through in their everyday lives. It deals with the good, bad, happy, sad . . . their church life, work life—stories and songs about life.

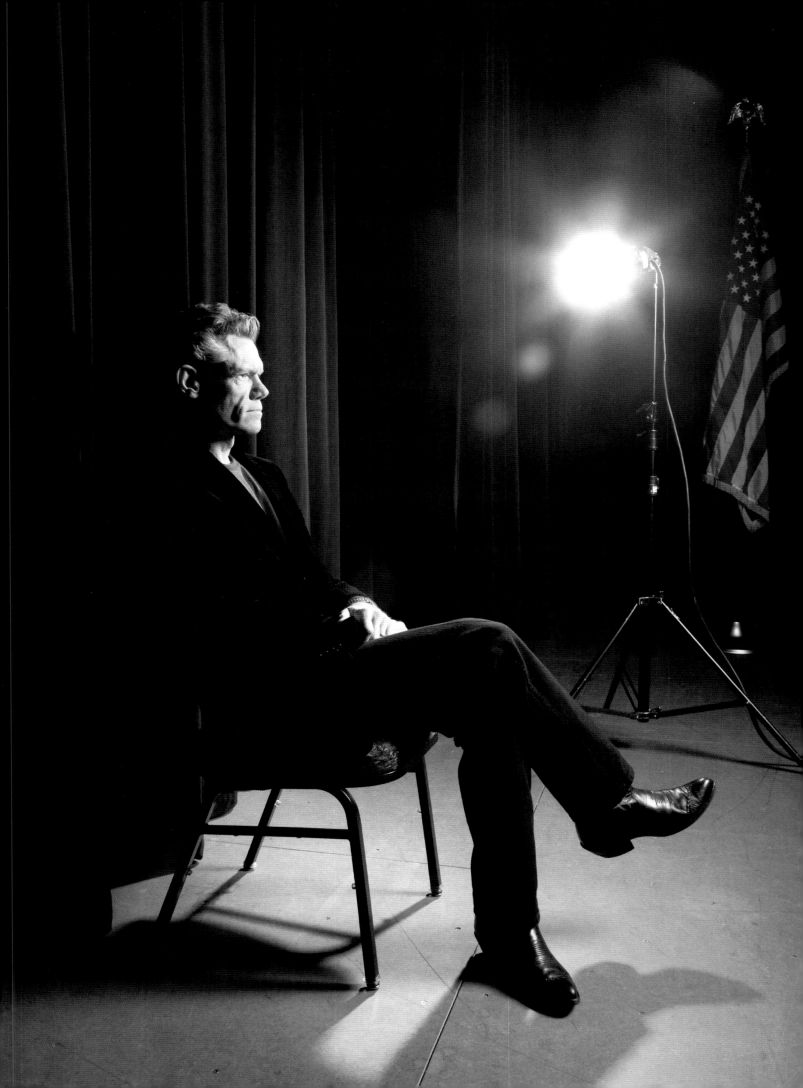

BLAKE SHELTON

DO YOU HAVE ANY SPECIAL THING YOU DO BEFORE YOU PERFORM?

Not really. For me, it's more of an all-day experience. On days when I have a show, I wake up in the morning and play country music all day long until I leave the bus and go onstage. I don't play to inspire myself to do a great job, but because I am a hard-core country music fan at heart.

DESCRIBE YOUR ULTIMATE MUSICAL PERFORMANCE.

I would have been born 20 years earlier and my first single would have come out in 1982 (during my favorite decade of country music). I could have made records that sounded like they sounded then. That would be the ultimate.

HAVE YOU EVER HEARD A SONG YOU WISH THAT YOU HAD WRITTEN?

Hell, yes, there are a hundred songs I wish I had written and a hundred reasons why. But if I had to pick one, I'd say I wish I had written "I'm No Stranger to the Rain," by Keith Whitley.

WAS THERE A MOMENT WHEN YOU KNEW YOU HAD TO BE A COUNTRY MUSICIAN?

I don't remember a specific moment, but I don't ever remember a time when music wasn't part of who I am. I am the only one in my family who had an interest in music, so throughout my life I always found music and would find a way to hear it, buy it, and eventually learn how to create it.

IF YOU WEREN'T A SINGER, WHAT WOULD YOU HAVE BEEN?

I would have ended up working construction, like most of the guys in my family.

IF YOU COULD THANK GOD IN PERSON FOR ONE THING, WHAT WOULD IT BE?

Second chances.

WHAT MAKES COUNTRY MUSIC THE HEART AND SOUL OF AMERICA?

It's unique to America; it was born here and it's continued to change along the years, musically. Country music is about real people, real experiences, and the real American lifestyle, and it changes from year to year and decade to decade. It is music that people can relate to in their everyday life, and that is why it will always be popular.

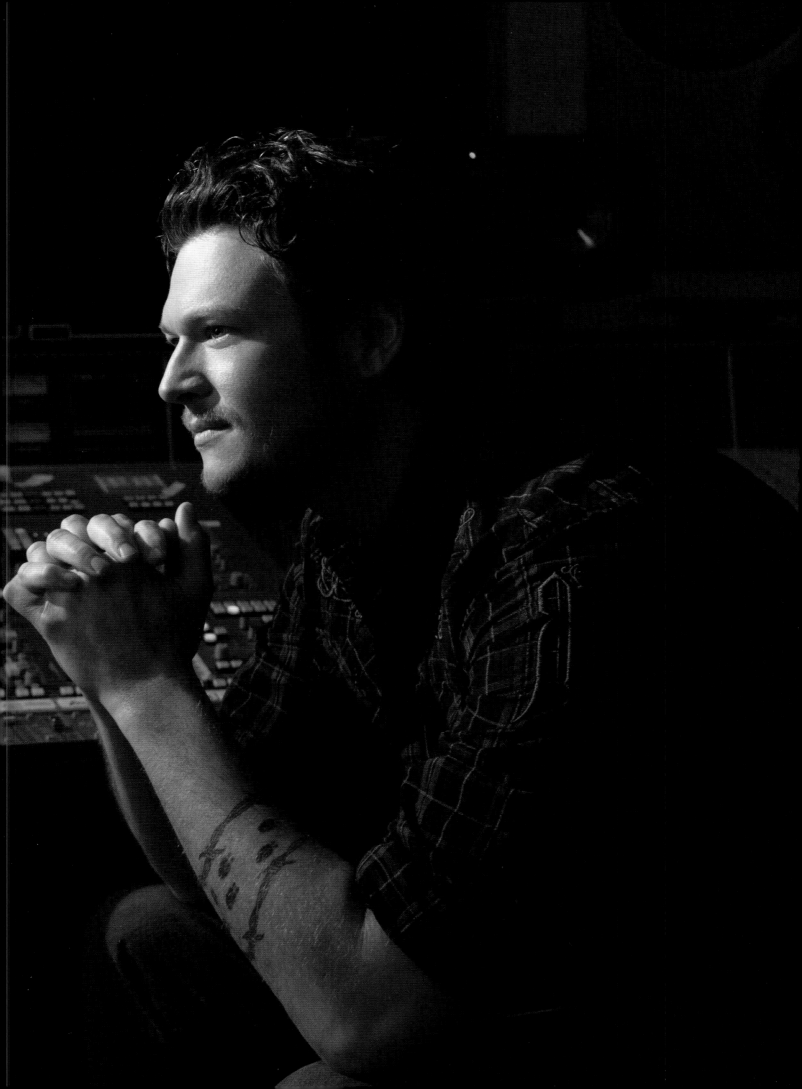

MARTY STUART

DESCRIBE YOUR ULTIMATE MUSICAL PERFORMANCE.

I have my ultimate musical performance every night, when I step on the stage with my band. My band is my legacy and every time we step up it happens. We are trying to help redefine and reintroduce traditional country music.

HAVE YOU EVER HEARD A SONG YOU WISH THAT YOU HAD WRITTEN?

Without a doubt, "Wichita Lineman."

WAS THERE A MOMENT WHEN YOU KNEW YOU HAD TO BE A COUNTRY MUSICIAN?

The first records I ever owned were Lester Flatt and Earl Scruggs and the fabulous Johnny Cash. It was the same time that the Beatles were really popular. When I started listening to them, I knew I wanted to be a country artist. After that, I gave my Beatles albums away.

DO YOU HAVE ANY SPECIAL THING YOU DO BEFORE YOU PERFORM?

I always pray.

IF YOU WEREN'T A SINGER, WHAT WOULD YOU HAVE BEEN?

An architect or a convict, whichever came first.

IF YOU COULD THANK GOD IN PERSON FOR ONE THING, WHAT WOULD IT BE?

The gift of music.

WHAT MAKES COUNTRY MUSIC THE HEART AND SOUL OF AMERICA?

Country music, when it does its job and is written and performed honestly, is a reflection of the everyday American—it reflects the heartache, tragedy, sadness, struggles, and victories of the everyday American. When times are good, we dance; when times are rough, we write songs about it to help us get through it and go on with life.

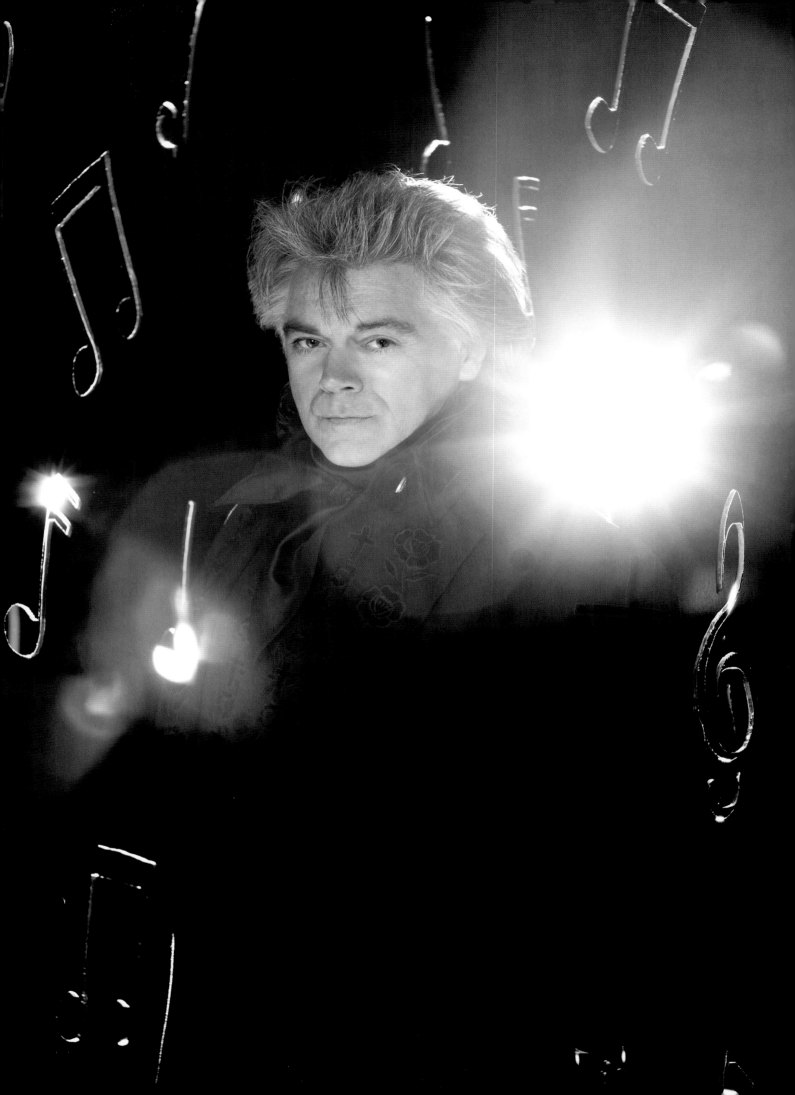

DESCRIBE YOUR ULTIMATE MUSICAL PERFORMANCE.

Talk about an impossible question. The joy is working with other people and never knowing who is going to be on the other end of the phone about the next collaboration. I guess I would pick my dad, sitting in the living room. It's where it all started and what was important to me as a kid.

HAVE YOU EVER HEARD A SONG YOU WISH THAT YOU HAD WRITTEN?

There've been so many great songs written . . . None of them—it robs the joy of what they are. Sometimes you can only really react honestly to something you have nothing to do with. I'm just grateful for the art of it.

WAS THERE A MOMENT WHEN YOU KNEW YOU HAD TO BE A COUNTRY MUSICIAN?

I started so young—in grade school playing for people. It was an obvious destiny.

DO YOU HAVE ANY SPECIAL THING YOU DO BEFORE YOU PERFORM?

No, absolutely not. I'm the most fly-by-the-seat-of-my-pants guy that ever walked the face of the Earth. Live music is so honest. It just goes out there in the air and then it's gone. Recording is equally compelling. Making a record is like having a child and watching him grow up.

IF YOU WEREN'T A SINGER, WHAT WOULD YOU HAVE BEEN?

An athlete of some sort. I was a decent ball player, and I'm a decent golfer.

IF YOU COULD THANK GOD IN PERSON FOR ONE THING, WHAT WOULD IT BE?

Grace.

WHAT MAKES COUNTRY MUSIC THE HEART AND SOUL OF AMERICA?

The believability. It seems to come from an honest place—real-life experience of hard times. I don't like the zip-a-dee-doo-dah music. I like the darker, real-life side of music.

DESCRIBE YOUR ULTIMATE MUSICAL PERFORMANCE.

I would perform for every single foster kid at a show so I could tell my story. Then they could see me, who's one of them, and it would give them hope. The location would be somewhere indoors so the kids would pay attention. I would play alone with my acoustic guitar.

HAVE YOU EVER HEARD A SONG YOU WISH THAT YOU HAD WRITTEN?

"Sara Smile," by Hall & Oates.

WAS THERE A MOMENT WHEN YOU KNEW YOU HAD TO BE A COUNTRY MUSICIAN?

When I was in high school, a convict from a local prison came and spoke to us. We were captivated while he told his story. He said, "Think smart; don't be like me." He was so inspiring, and he said, "I sing country music," and at that moment, that's when I knew that's what I wanted to do.

DO YOU HAVE ANY SPECIAL THING YOU DO BEFORE YOU PERFORM?

I warm up, stretch, and drink water.

IF YOU WEREN'T A SINGER, WHAT WOULD YOU HAVE BEEN?

I like history, so maybe I would have been a history teacher, or maybe a photographer.

IF YOU COULD THANK GOD IN PERSON FOR ONE THING, WHAT WOULD IT BE?

My foster parents, Beatrice and Russell Costner.

WHAT MAKES COUNTRY MUSIC THE HEART AND SOUL OF AMERICA?

Country music is a universal language, and the stories are those that most people can relate to.

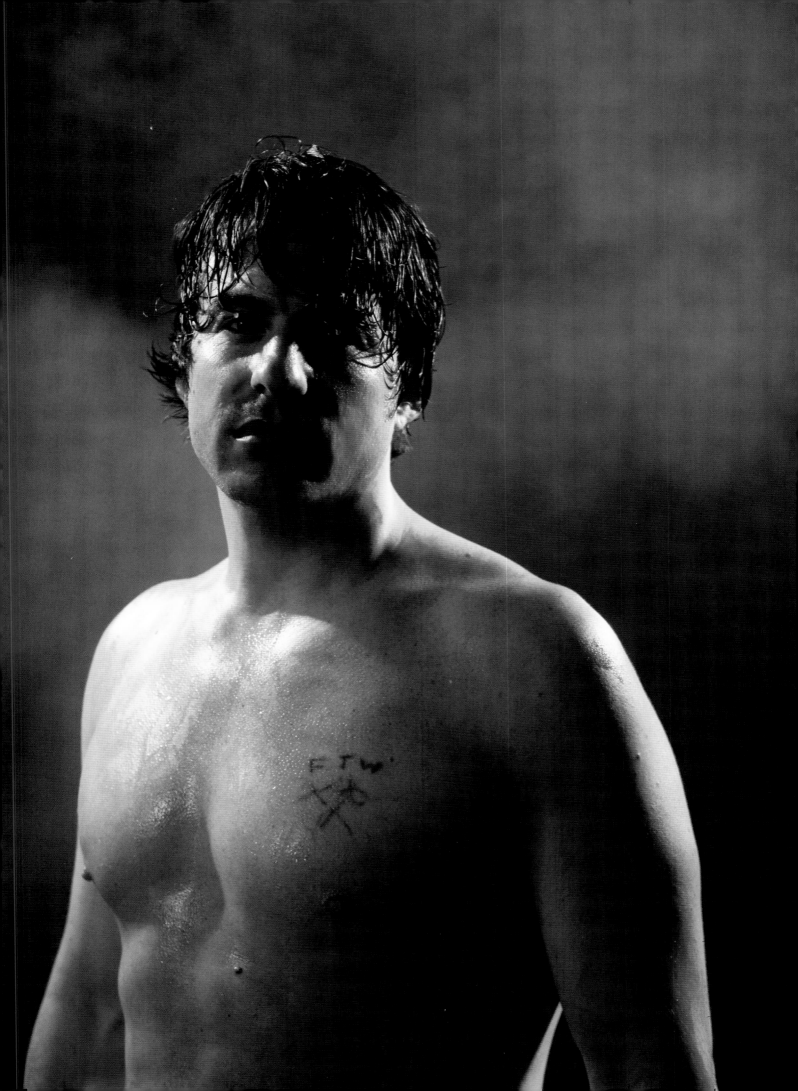

DESCRIBE YOUR ULTIMATE MUSICAL PERFORMANCE.
We did a gig recently in a church. The sound was amazing, and it was for just 200 people. If you wanted to have the greatest band in the world, you'd have Satchmo on the trumpet, Max Roach on the drums. And Les Paul.

HAVE YOU EVER HEARD A SONG YOU WISH THAT YOU HAD WRITTEN?
"Rainy Night in Georgia." "Help Me Make It Through the Night." "Crazy."

WAS THERE A MOMENT WHEN YOU KNEW YOU HAD TO BE A COUNTRY MUSICIAN?
No, that's all I've ever done. It's the most natural thing. It's like breathing.

DO YOU HAVE ANY SPECIAL THING YOU DO BEFORE YOU PERFORM?
Drink champagne. It's a great buzz, but you can only drink so much, and it lasts a long time.

IF YOU WEREN'T A SINGER, WHAT WOULD YOU HAVE BEEN?
I love to paint. And I'm a pretty good shrink.

IF YOU COULD THANK GOD IN PERSON FOR ONE THING, WHAT WOULD IT BE?
For giving me a charmed life. There is absolutely nothing wrong with my life.

WHAT MAKES COUNTRY MUSIC THE HEART AND SOUL OF AMERICA?
I'm a traditionalist. I'm country. I'm from the country. Country music to me is Hank Williams. I'm not into the modern stuff. It's a common man's blues. The old blues cats took from country in the Hank Williams days because it's the common man's blues. It's the nucleus of, "Hey, I feel that, too. I know what you mean."

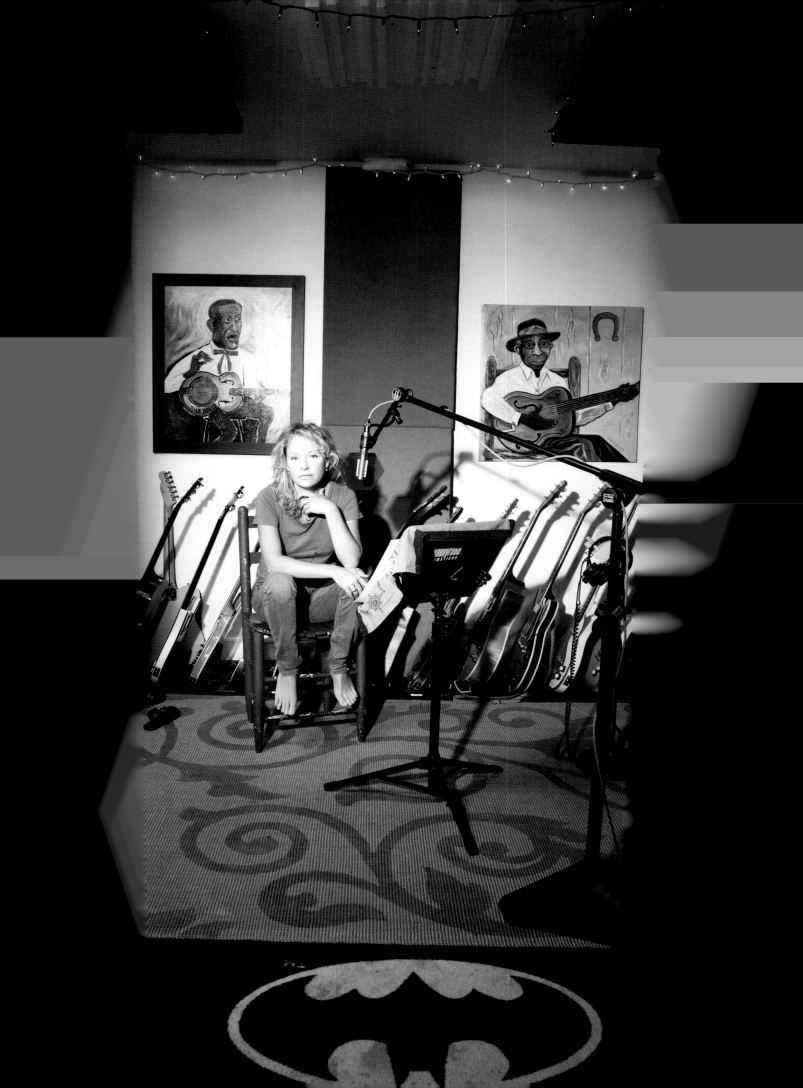

Ronnie Dunn

WHAT MAKES COUNTRY MUSIC THE HEART AND SOUL OF AMERICA?

For the most part, today's country music has something for everyone. If I had to pinpoint one definitive dynamic, it would be that it attempts to keep a finger on the pulse of middle America. We've had 'em dancin' in the streets in Manhattan. We seen 'em throw down in Texas. I think it's a mistake to box it in too tight.

DESCRIBE YOUR ULTIMATE MUSICAL PERFORMANCE.

The Second Coming: Merle Haggard on electric rhythm guitar. Willie Nelson on acoustic rhythm guitar. Hank Williams on high string acoustic. Billy Gibbons, Keith Richards on electric lead guitar. Sting on bass. Tina Turner background vocals. Jim Keltner on drums. Elvis and Johnny Cash. I think they both negotiated often with God during their stay here on planet Earth. We'd open with "Hail to the Chief" and encore with "I Saw the Light"!

HAVE YOU EVER HEARD A SONG YOU WISH THAT YOU HAD WRITTEN?

I wish I'd written "You Don't Know Me."

WAS THERE A MOMENT WHEN YOU KNEW YOU HAD TO BE A COUNTRY MUSICIAN?

I knew that I wanted to be a country singer three songs into Willie's Nelson's *Phases and Stages* album.

DO YOU HAVE ANY SPECIAL THING YOU DO OR A TRADITION BEFORE YOU PERFORM?

I always try to get an hour nap in before a show. Johnny Cash gave me that tip. It changes the world.

IF YOU WEREN'T A SINGER, WHAT WOULD YOU HAVE BEEN?

Who says I'm a singer?

IF YOU COULD THANK GOD IN PERSON FOR ONE THING, WHAT WOULD IT BE?

If I could thank God in person, I would thank him for carrying around a pocketful of second chances.

Kix Brooks

DESCRIBE YOUR ULTIMATE MUSICAL PERFORMANCE.
We got a chance to do a Crossroads special for Country Music Television with ZZ Top a few years back in Nashville, and I can't imagine it getting any better than that. I grew up chasing those guys, and it was the ultimate to have them playing our songs and getting to play and sing those great Top songs with them.

HAVE YOU EVER HEARD A SONG YOU WISH THAT YOU HAD WRITTEN?
I hear songs I wish I'd written every day. I'm a huge fan of music and talent, and there are lots of peeps out there who can do it better than me. Keeps me inspired!

WAS THERE A MOMENT WHEN YOU KNEW YOU HAD TO BE A COUNTRY MUSICIAN?
In the early '70s when I first got introduced to the great Texas singer songwriters—Guy Clark, Townes, Willie and Waylon, Jerry Jeff—I just wanted to be like them.

DO YOU HAVE ANY SPECIAL THING YOU DO BEFORE YOU PERFORM?
Shot of Crown right before I go on! No drinking during the day!

IF YOU WEREN'T A SINGER, WHAT WOULD YOU HAVE BEEN?
I liked the ad biz. I worked for my sister when I got out of college and really loved my years on the pipeline—my dad was a pipeline contractor, and I think I could be happy on a bulldozer.

IF YOU COULD THANK GOD IN PERSON FOR ONE THING, WHAT WOULD IT BE?
Giving me such a wonderful life. Why me?

WHAT MAKES COUNTRY MUSIC THE HEART AND SOUL OF AMERICA?
The stories of real people's everyday stuff.

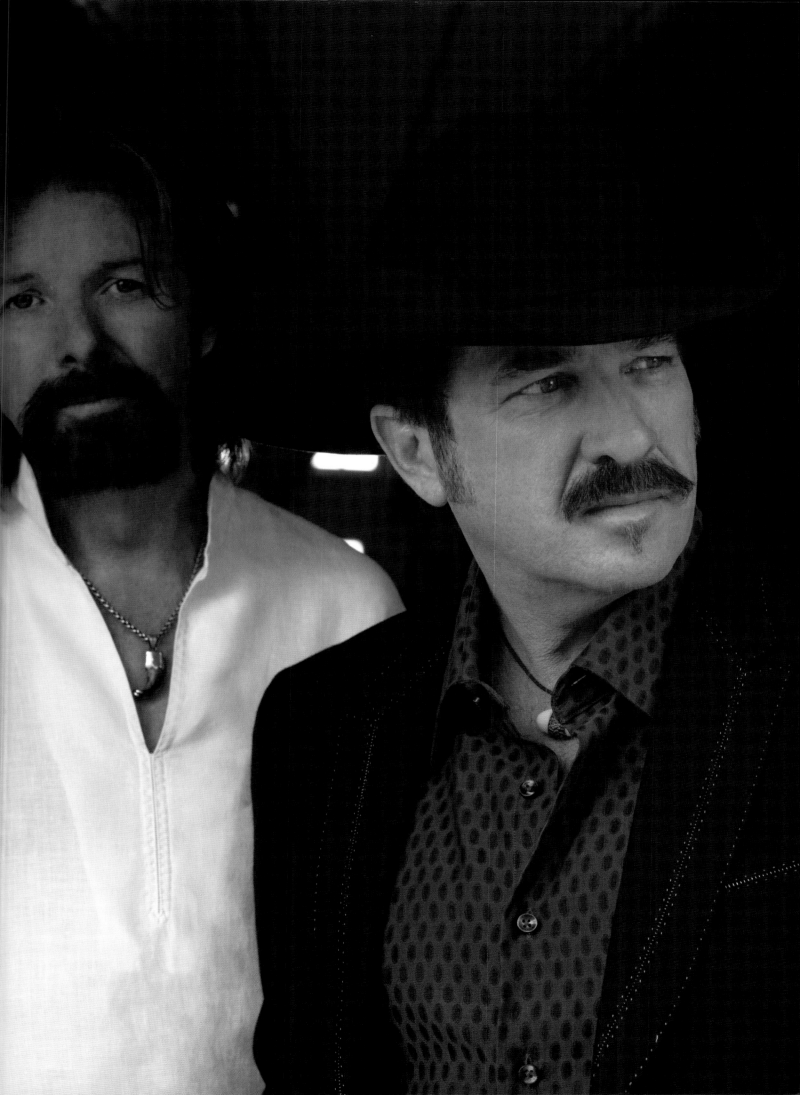

JACK INGRAM

DESCRIBE YOUR ULTIMATE MUSICAL PERFORMANCE.

My ultimate time/place/setting for making music is a room full of people who care as much about songs as I do. Playing for people with passion for music is what it's all about . . . that and money!

HAVE YOU EVER HEARD A SONG YOU WISH THAT YOU HAD WRITTEN?

Yes. It happens every day. In fact, it's part of the main motivation that gets me writing songs. I am always trying to write something better than the last song I heard that I wish I'd written.

WAS THERE A MOMENT WHEN YOU KNEW YOU HAD TO BE A COUNTRY MUSICIAN?

The first time I finished writing a song and played it in front of an audience. I knew at that point that this was what I was going to chase.

DO YOU HAVE ANY SPECIAL THING YOU DO BEFORE YOU PERFORM?

Yes. I listen to good music: Todd Snider, the Rolling Stones, Willie Nelson, Jerry Jeff Walker, Bob Schneider, Patty Griffin, Tom Petty, Tom Waits, Tom T. Hall—anybody named Tom. The list goes on and on. And I drink a cold beer. It gets me rolling and ready.

IF YOU WEREN'T A SINGER, WHAT WOULD YOU HAVE BEEN?

I graduated from college with a degree in psychology. I always have had an interest in why we are all so messed up: self-esteem, anxiety, depression—again, the list is long! It's the same reason I started writing songs. If this hadn't worked out, I probably would be listening to some overprivileged, unhappy dude telling me about his problems right now! This is probably more my speed.

IF YOU COULD THANK GOD IN PERSON FOR ONE THING, WHAT WOULD IT BE?

Personally: I have a beautiful family that has, by far, taken the lead over music in the race for what I live for. Thanks for that.
Professionally: I am able to take my experiences in this world and put them to words and music that make it all make sense in some way. I am grateful for that. The fact that I can relate that to other people in a way that is meaningful for them and make a living doing it . . . thank YOU for that.

WHAT MAKES COUNTRY MUSIC THE HEART AND SOUL OF AMERICA?

Storytelling. When kids go to sleep, stories make them feel better and feel like they fit in this world. That really never changes. Country music is storytelling, at its core.

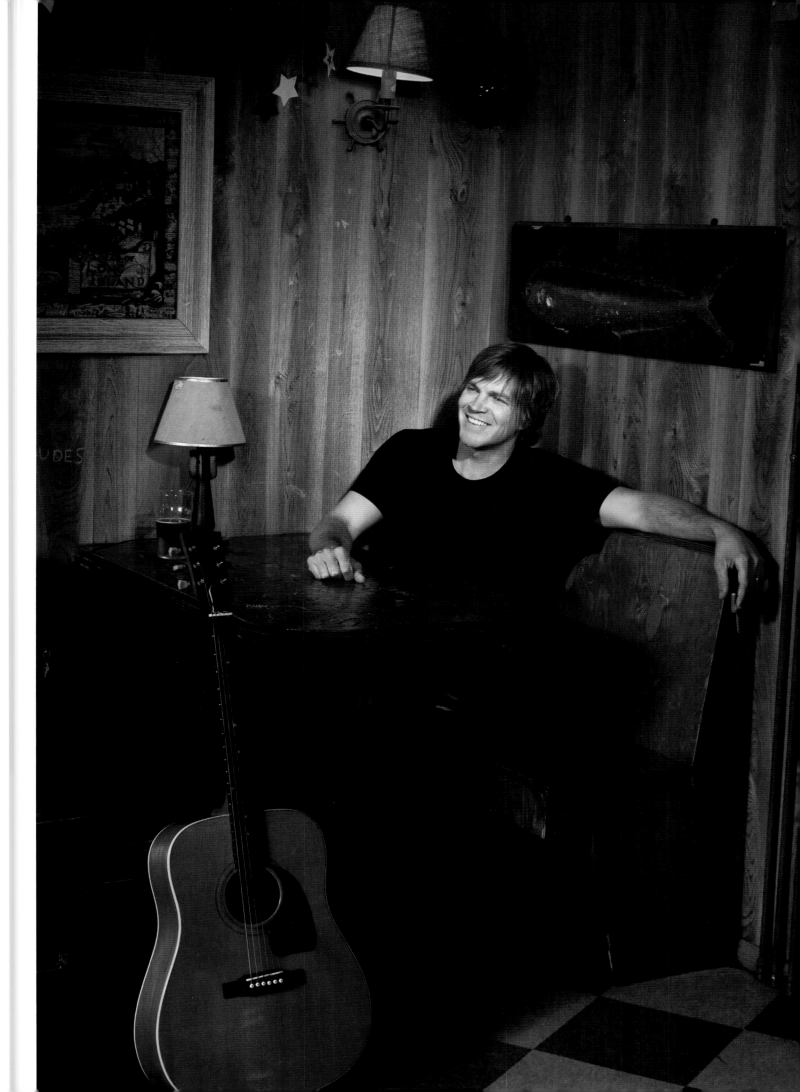

★ LEE ANN WOMACK ★

DESCRIBE YOUR ULTIMATE MUSICAL PERFORMANCE.

Somewhere in Texas. Plenty of cold beer. Plenty of steel guitar. Every musician that I've worked with, played on my records, or traveled with me. Bunch of people who really love traditional country music.

HAVE YOU EVER HEARD A SONG YOU WISH THAT YOU HAD WRITTEN?

"Crazy," by Willie Nelson.

WAS THERE A MOMENT WHEN YOU KNEW YOU HAD TO BE A COUNTRY MUSICIAN?

I remember seeing Dolly Parton on TV and thinking, "That's what I want to do."

DO YOU HAVE ANY SPECIAL THING YOU DO BEFORE YOU PERFORM?

I just like to hang out in the dressing room with my band guys. They're always laughing and really enjoy what they do. I love being with them.

IF YOU WEREN'T A SINGER, WHAT WOULD YOU HAVE BEEN?

I had considered going into radio because my dad and his brother had done that from the time they were teenagers. I was friendly with his former boss at the radio station in our hometown and talked to him about it.

IF YOU COULD THANK GOD IN PERSON FOR ONE THING, WHAT WOULD IT BE?

My parents, my husband, and my children.

WHAT MAKES COUNTRY MUSIC THE HEART AND SOUL OF AMERICA?

Well, country music is American music. It's one of the few art forms that we can claim as our own. That's because it's told the American story from its beginnings.

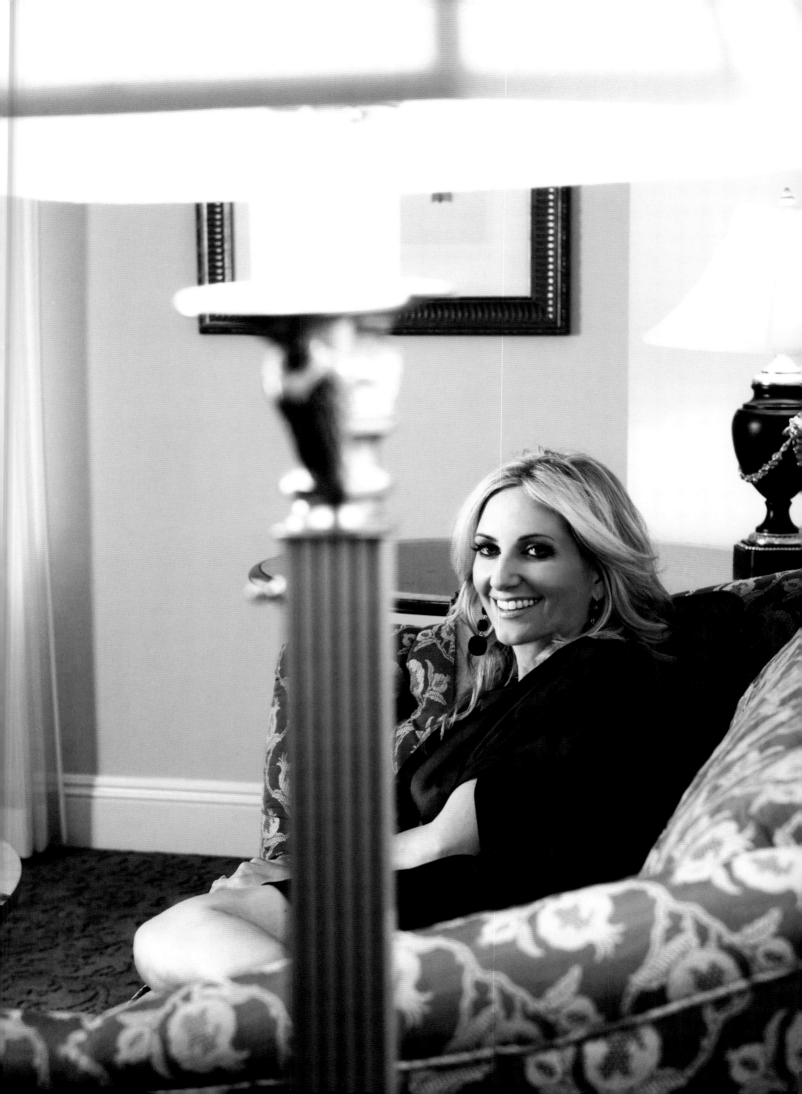

DWIGHT YOAKAM

DESCRIBE YOUR ULTIMATE MUSICAL PERFORMANCE.

Any that reminds me of the thrill and excitement of playing music in front of a live audience at 16 . . . or feels as exciting as it was to watch a performance of many of my musical heroes on television when I was a kid.

HAVE YOU EVER HEARD A SONG YOU WISH THAT YOU HAD WRITTEN?

Anthony Crawford's "V's of Birds." The first time I heard the opening line of lyrics I stopped in my steps. They're as elegant as the prose at the beginning of any novel I've ever read.

WAS THERE A MOMENT WHEN YOU KNEW YOU HAD TO BE A COUNTRY MUSICIAN?

No. But the sense that I was always possessed me . . . over the years of backseat car rides from Kentucky to Ohio and back.

DO YOU HAVE ANY SPECIAL THING YOU DO BEFORE YOU PERFORM?

Yes, but I won't discuss it.

IF YOU WEREN'T A SINGER, WHAT WOULD YOU HAVE BEEN?

A friend who was interviewing me once asked me this question and quickly said they would propose as an answer, industrial designer. And I guess they may be right. My inclination is to design things, although I lack the formal training. I've always been a fan of Raymond Loewy and Coco Chanel. Go figure. If you have any sense of how dramatically both of those individuals have shaped 20th-century contemporary pop culture, you will understand.

IF YOU COULD THANK GOD IN PERSON FOR ONE THING, WHAT WOULD IT BE?

The opportunity and the journey.

WHAT MAKES COUNTRY MUSIC THE HEART AND SOUL OF AMERICA?

When it's done with instinctive purity, as with the other uniquely American musical forms—blues, rock 'n' roll, jazz—it can express universally held emotional truths.

Barbara ★ Mandrell

"Battle Hymn of the Republic"

"I Left My Heart in San Francisco," Tony Bennett

"Amazing Grace"

"He Grew the Tree" [*She was the first to record this song.*]

"Jesus Loves Me This I Know"

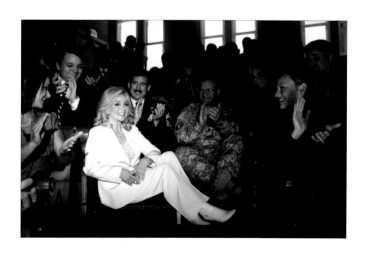

Bill Anderson

"The Song Remembers When"

"I Wonder Where You Are Tonight"

"Wedding Bells"

"Just a Closer Walk with Thee"

"When I Get Where I'm Going"

BLAKE SHELTON

"What I'd Say," Earl Thomas Conley

"Let Your Love Flow," the Bellamy Brothers

"A Country Boy Can Survive," Hank Williams Jr.

"Will the Circle Be Unbroken," Nitty Gritty Dirt Band

"I'm No Stranger to the Rain," Keith Whitley

BRAD PAISLEY ♫

"The Chair"

"I've Got a Tiger by the Tail"

"Good Ole Boys Like Me"

"I Can't Make You Love Me"

"Layla"

BROOKS & DUNN

RONNIE DUNN

Way too many!

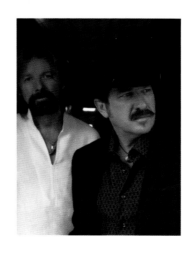

BROOKS & DUNN

KIX BROOKS

"The Way I Am," Merle Haggard

"Sunday Morning Coming Down," Kris Kristofferson

"L.A. Freeway," Jerry Jeff Walker

"Let Him Roll," Guy Clark

"The Heart of Saturday Night," Tom Waits

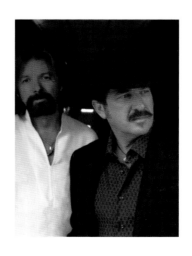

CARRIE UNDERWOOD

"When I Get Where I'm Going," Brad Paisley

"The World I Know," Collective Soul

"Have You Ever Seen the Rain," Creedence Clearwater Revival

"Welcome Home," Dolly Parton

"Beautiful Day," U2

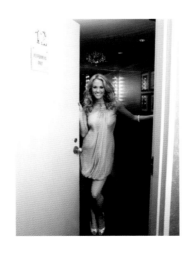

CHARLEY PRIDE

"It Only Hurts for a Little While," the Ames Brothers

"Love Is a Many Splendored Thing," the Four Aces

"Bless Yore Beautiful Hide," Howard Keel

"Footprints in the Snow"

"Mansions for Me"

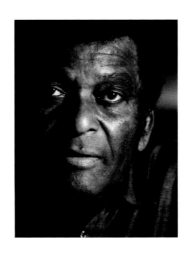

CLINT BLACK

This is impossible, but here's how the list would look today:

"The Prayer," as recorded by Andrea Bocelli and Heather Headley

"Thanks Again"

"Desperado"

"When I Said I Do"—yes, one of mine!—because of what it says about my marriage.

The theme song from *Somewhere in Time*.

CRYSTAL GAYLE

My taste in music ranges from Billie Holiday to Alan Jackson, the *Sesame Street* songs—I love those. I'm just a lover of music. It's just too hard to pick one song. It's a mood for me. I like the New Age music with the Indian flutes. I've always liked Melanie. Cyndi Lauper—"Girls Just Wanna Have Fun," the Beatles—"Yesterday," Loretta's "Don't Come Home A-Drinkin' (With Lovin' on Your Mind)." Also, Brenda Lee's "All Alone Am I." I used to put her records on and record myself singing her songs.

DARIUS RUCKER

"Welcome to the Future," Brad Paisley

"More Like Her," Miranda Lambert

"For the Good Times," Al Green

"You Can Come Cryin' to Me," Foster & Lloyd

"I Can't Make You Love Me," Bonnie Raitt

DAVID ALLAN COE

"Follow Me," Uncle Kracker

"Single Father," a song I wrote for Kid Rock

"Whiskey River," Willie Nelson

"Southern Man," Neil Young

"These Days," Jackson Browne

DWIGHT YOAKAM

As soon as I think of 5, I realize there are 25, and at that moment there are 50 more. On any given day there are just too many places to start that list.

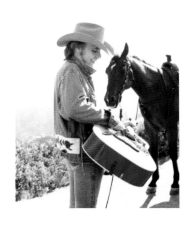

GEORGE JONES

Five of my favorite artists:
Hank Williams, Roy Acuff, Lefty Frizzell, Patsy Cline, and Tammy Wynette

Five of my favorite songs:
"You Win Again," Hank Williams
"When I Call Your Name," Vince Gill
"Me and Jesus," Tom T. Hall
"Too Cold at Home," Mark Chesnutt
"Stand by Your Man," Tammy Wynette

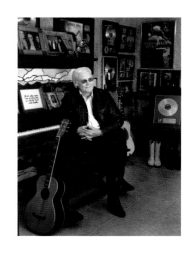

Glen Campbell

"Yesterday," the Beatles

"Without You"

"Postcard from Paris," John Denver

And so many more . . .

GRETCHEN WILSON

"Don't Let Me Be Lonely Tonight," James Taylor

"Coal Miner's Daughter," Loretta Lynn

"Ride On," AC/DC

"Silver Wings," Merle Haggard

"Cry Baby," Janis Joplin

HEIDI NEWFIELD

"Lonesome, On'ry and Mean," Waylon Jennings
"The Way I Am," Merle Haggard
"At Last," Etta James
"You Ain't Woman Enough," Loretta Lynn
"Proud Mary," Tina Turner
"Folsom Prison Blues" or "Hurt," Johnny Cash
(There are way too many songs and artists that
have influenced me to name them all.)

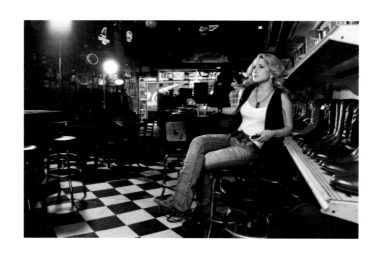

JACK INGRAM

"Blue Eyes Crying in the Rain," Willie Nelson

"American Girl," Tom Petty and the Heartbreakers

"Stuff That Works," Guy Clark

"The Heart of Saturday Night," Tom Waits

The next song I write . . . it's the reason I do this.

JAKE OWEN

"Good Friends, Good Whiskey, Good Lovin'," Hank Williams Jr.

"She Believes in Me," Kenny Rogers

"Going Where the Lonely Go," Merle Haggard

"The Blues Man," Hank Williams Jr.

"I Believe in You," Don Williams

JD SOUTHER

The Goldberg Variations (J. S. Bach), all of them, performed by Glenn Gould

"I'm So Lonesome I Could Cry," written and performed by Hank Williams

"Drown in My Own Tears" (H. Glover), live version performed by Ray Charles

"Bye Bye Blackbird" (R. Henderson and M. Dixon), performed by Miles Davis

"Tangled Up in Blue," written and performed by Bob Dylan

Okay, I know, this is six: "Wichita Lineman" (J. Webb), performed by either Glen Campbell or Jimmy Webb

All right, seven: "Ev'ry Time We Say Goodbye" (Cole Porter), performed by John Coltrane or Betty Carter and Ray Charles

One more—eight: "This Land Is Your Land," music adapted and lyrics by Woody Guthrie, performed by Woody Guthrie

If I just got one, it would be Bach.

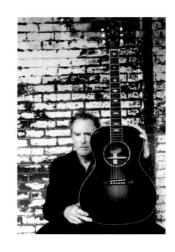

JIM LAUDERDALE

"Rank Stranger," the Stanley Brothers

"She's Mine," George Jones

"I'm Always on a Mountain When I Fall," Merle Haggard

"I Thought I Heard You Calling My Name," Porter Wagoner

"Lonesome Whistle," Hank Williams

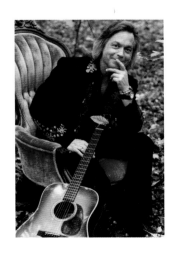

JIMMY WAYNE

"Sara Smile," Hall & Oates

The album *Empire,* Queensryche

"Chasin' That Neon Rainbow," Alan Jackson

"Careless Whisper," Wham!

Anything by Rammstein

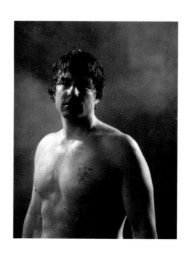

JOE NICHOLS

Anything by Merle Haggard

Anything from the '70s by Hank Williams Jr.

Keith Whitley

Jazz: Louis Armstrong, Duke Ellington, Ella Fitzgerald

JOHN RICH

"My Way," Frank Sinatra

"Ring of Fire," Johnny Cash

"You Shook Me All Night Long," AC/DC

"Are You Sure Hank Done It This Way?" Waylon Jennings

"The Ballad of Curtis Loew," Lynyrd Skynyrd

JOSH TURNER

Choosing the song is difficult because I can find something redeeming in almost every song. But for artists, I have my Mount Rushmore of country music. These five guys made and continue to make a huge impact on me and my music.

Randy Travis

Johnny Cash

John Anderson

Vern Gosdin

Hank Williams

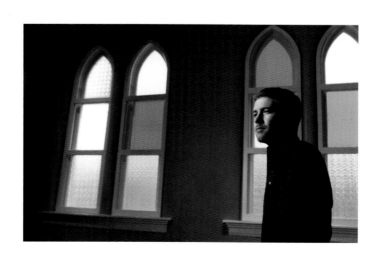

JULIANNE HOUGH

"Breathe," Faith Hill

"Live Like You Were Dying," Tim McGraw

"Independence Day," Martina McBride

"Crazy," Patsy Cline

"Stronger Woman," Jewel

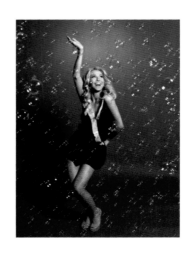

KENNY CHESNEY

"Hallelujah," Jeff Buckley

"These Days," Jackson Browne

"My Hometown," Bruce Springsteen

"Three Little Birds," Bob Marley

"Bartender's Blues," George Jones

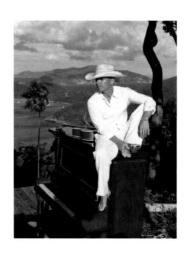

KENNY ★ ROGERS

I would have to say number one on that list would be Ray Charles. Any song I picked to start with would have to be Ray Charles. I was really lucky because he was such an influence on me as a kid coming up. When I was 12 years old I went to hear him sing, and I realized at that point that this was what I wanted to do, because everybody laughed at what he said and clapped at what he sang. He's kind of the end-all, cure-all for me. Other artists who I really, really admire . . . I go back to Lionel Richie. I think he's a pure singer who writes great music. Of course, I was in jazz for 10 years, so you have to forgive me if I digress, but groups like the Four Freshman were great inspirations to me as well.

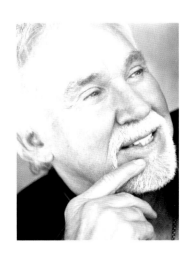

★ LEE ANN WOMACK ★

"Crazy," Willie Nelson

"A Good Year for the Roses," George Jones

"Marina del Ray," George Strait

"Highway 40 Blues," Ricky Skaggs

"Jolene," Dolly Parton

LITTLE BIG TOWN

GROUP ANSWER

"To Make You Feel My Love," performed by Adele, written by Bob Dylan

"Blue Eyes Crying in the Rain," Willie Nelson

"Jolene," Dolly Parton

"Isn't She Lovely," Stevie Wonder

"I Shall Be Released," performed by the Band, written by Bob Dylan

LITTLE JIMMY DICKENS

Leaving Hank Williams out, because he was the greatest writer that ever lived, and Merle Haggard—the songs that he's written are all his experiences in life; not too many people write about their experiences in life. "Today I Started Loving You Again." Every time I think about that song, I get a cold chill. I start loving my wife again every day. She's so special, she understands me, she knows when I'm down, she's knows when I'm up—we're that close. "How Great Thou Art," by Connie Smith. You've never heard anything till you've heard that.

MARTINA McBRIDE

I am inspired by Aretha Franklin, Eva Cassidy, Merle Haggard, the Beatles, Annie Lennox—by anybody who has made music that is honest and soulful. These are just a few of the people I look up to. They have left behind a legacy of music that is forever a part of our lives and the lives of generations to come. I can only aspire to do that.

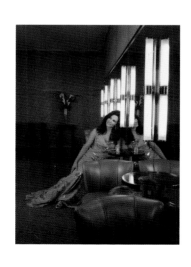

MARTY STUART

These are five of my favorite albums:

Johnny Cash, *At Folsom Prison*

The Best of Merle Haggard

The Essential Jimmie Rodgers

Bill Monroe & His Bluegrass Boys

Connie Smith, *Miss Smith Goes to Nashville*

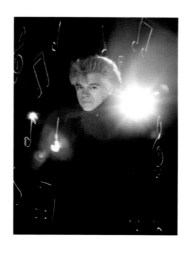

MEL TILLIS

"Just a Closer Walk with Thee," Red Foley

"Wind Beneath My Wings," Bette Midler

"I Love You Because," Leon Payne

"Watermelon Wine," Tom T. Hall

"I'm So Lonesome I Could Cry," Hank Williams

MIRANDA LAMBERT

"The Way I Am," Merle Haggard

"Desperados Waiting for a Train," Guy Clark

"Alabama Song," Allison Moorer

"What Makes You Say," Jack Ingram

"Halo," Beyoncé

PATTY LOVELESS

"Imagine," John Lennon

"Yesterday," the Beatles

"We've Got Tonight," Bob Seger

"Nobody's Girl," Bonnie Raitt

"I Will Always Love You," Dolly Parton

"These Arms of Mine," Otis Redding

RANDY TRAVIS

"I'm So Lonesome I Could Cry," Hank Williams

"He Stopped Loving Her Today," George Jones

"Precious Lord" (a gospel song)

Merle Haggard's . . . anything

"The Grand Tour," George Jones

RAY BENSON

Unlike a lot of musicians, my taste runs the gamut. In my car, I have the satellite radio, the cassette player, the CD player, and regular radio. I constantly go back and forth through all of the options. I might start with Bach, go to Hank Williams, then Coltrane, then Frank Sinatra, Willie Nelson, and on and on.

REBA McENTIRE

"I'm a Survivor"

"The Star-Spangled Banner"

"Jesus Loves Me"

"O Holy Night"

"America the Beautiful"

♫ RODNEY ATKINS ♪

Not in any particular order:

"Live Like You Were Dying"

"If You're Going Through Hell"

"I Can See Clearly Now"

"Bridge Over Troubled Water"

"When I Get Where I'm Going"

 # RODNEY CROWELL

"Tango till They're Sore," Tom Waits

"Hey Good Lookin'," Hank Williams

"Sunday Mornin' Comin' Down," Kris Kristofferson

"Every Grain of Sand," Bob Dylan

"Let Him Fly," Patty Griffin

ROSANNE CASH

"Gimme Shelter," the Rolling Stones

"Here, There and Everywhere," the Beatles

"Born to Run," Bruce Springsteen

"Like a Rolling Stone," Bob Dylan

"Chain of Fools," Aretha Franklin

♫ ROY CLARK ♫

"Yesterday When I Was Young"

"Cold, Cold Heart," Hank Williams

"Peace in the Valley," my version

"You're the Only Star (in My Blue Heaven)," Gene Autry

So many songs by Hank Williams

SHELBY LYNNE

I like to listen to Ella Fitzgerald. Traditional jazz really moves me—the horns, the melodies. Louis Armstrong singing "How Long Has This Been Going On." Ray Charles, "Georgia on My Mind." Frank Sinatra, "One for My Baby (and One More for the Road)." And I have my guilty pleasures . . . Gino Vannelli, "Living Inside Myself." George Jones singing "He Stopped Loving Her Today." You've gotta have George Jones singing that.

SUGARLAND

JENNIFER NETTLES

"In Your Eyes," Peter Gabriel

"He Stopped Loving Her Today," George Jones

"Crash into Me," the Dave Matthews Band

"Defying Gravity," Steven Schwartz

"Black Muddy River," the Grateful Dead, as performed by Bruce Hornsby

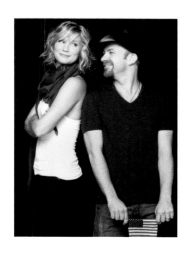

★ SUGARLAND ★

KRISTIAN BUSH

"I Still Haven't Found What I'm Looking For," U2

"Forever and Ever, Amen," Randy Travis

"Into the Mystic," Van Morrison

"So Lonely," the Police

"One Love," Bob Marley

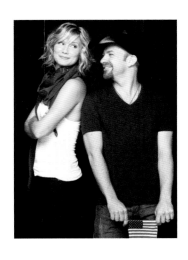

TAYLOR SWIFT

"You're So Vain," Carly Simon

"One," U2

"You Were Mine," Dixie Chicks

"Breathe," Faith Hill

"Can't Tell Me Nothin'," Tim McGraw

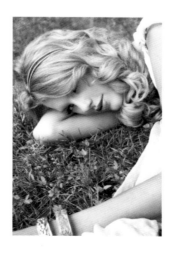

THE OAK RIDGE BOYS

WILLIAM LEE GOLDEN

"Over the Rainbow"

"Tennessee Waltz"

"Love Is a Many Splendored Thing"

"Amazing Grace"

"Time Has Made a Change in Me"

THE OAK RIDGE BOYS

JOE BONSALL

"I Believe in a Hill Called Mount Calvary," Bill Gaither

"Turn Your Eyes Upon Jesus"

"I Love to Tell the Story"

"Because He Lives," Bill Gaither

"He Did It All for Me," Duane Allen

THE OAK RIDGE BOYS

RICHARD STERBAN

"You Needed Me," Anne Murray

"Zion Gate," Quito Rymer

Anything by Kenny Chesney

Anything by Andrea Bocelli

Anything by Michael Bublé (my daughter introduced me)

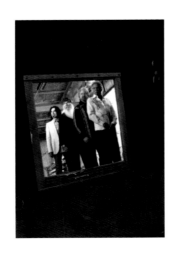

THE OAK RIDGE BOYS

DUANE ALLEN

My musical tastes span all types of music: from classical to the Metropolitan Opera to the Grand Ole Opry. My favorite country songs are the ballads, usually about "the one I love"—though the one song that is not about love at all, "Elvira," has paid more bills for me than any other song. My influences go beyond the music. They're more about the people in the business. People like Johnny Cash, Jimmy Dean, Roy Clark, Jim Halsey, Mel Tillis, and Kenny Rogers. These men took the Oak Ridge Boys to the big stages all over the Earth.

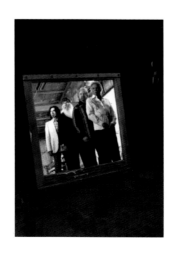

TRACE ADKINS ♫

"The Way I Am," Merle Haggard

"Together Again," Buck Owens

"Hold On Loosely," .38 Special

"Good Ole Boys Like Me," Don Williams

"Chiseled in Stone," Vern Gosdin

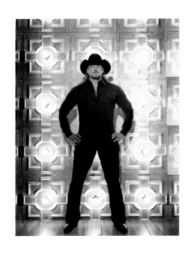

Trisha Yearwood

These are the artists who really shaped the kind of music that I do:

Linda Ronstadt
Patsy Cline
Elvis Presley
Judy Garland
The Eagles
Elton John

VINCE GILL

I guess for me it would be different artists by decade:

'30s: Billie Holiday

'40s: Bob Wills

'50s: Chuck Berry, Hank Williams, the Everly Brothers, Patsy Cline

'60s: Buck Owens, the Beatles

'70s: Bands like the Eagles, Steely Dan, and Fleetwood Mac

WYNONNA JUDD

"Amazing Grace"

"Taps"

"How Great Thou Art"

"Over the Rainbow"

The theme song from *The Andy Griffith Show*

WHO, WHEN AND WHERE

AND

Who	Where	When	Photo / Questions	Playlist
Barbara Mandrell	Ryman Auditorium, Nashville, Tennessee	May 18, 2009	40-43	131
Bill Anderson	Hall of Fame Rotunda, Country Music Hall of Fame, Nashville	July 9, 2009	60-61	132
Blake Shelton	Starstruck Studios, Nashville	Febuary 24, 2010	106-109	133
Brad Paisley	Mr. Paisley's house, Franklin, Tennessee	October 12, 2005	48-49	134
Brooks & Dunn	Ronnie Dunn's barn/recording studio, Nashville	June 11, 2009	118-121	135-136
Carrie Underwood	The Women of Country dressing room, Grand Ole Opry House, Nashville	June 9, 2009	20-21	137
Charley Pride	El Fenix Famous Mexican Restaurant, Dallas, Texas	August 17, 2009	18-19	138
Clint Black	The Four Seasons Hotel, Las Vegas, Nevada	May 16, 2008	98-99	139
Crystal Gayle	The recording studio at Crystal Gayle Enterprises, Nashville	August 25, 2009	90-91	140
Darius Rucker	Castle Recording Studio, Franklin, Tennessee	January 7, 2009	74-77	141
David Allan Coe	Sidewalk in front of the West Shore Hardware Bar, Mechanicsburg, Pennsylvania	August 6, 2009	32-33	142
Dwight Yoakam	Hollywood Bowl Overlook, Hollywood, California	July 24, 2009	126-127	143
George Jones	The basement of Mr. Jones' house, Franklin, Tennessee	June 11, 2009	96-97	144
Glen Campbell	Westward Beach, Malibu, California	July 1, 2009	70-71	145
Gretchen Wilson	Ms. Wilson's house, Lebanon, Tennessee	January 9, 2010	102-103	146
Heidi Newfield	Robert's Western Wear, Nashville	March 15, 2010	24-27	147
Jack Ingram	Rusty Knot, New York, New York	March 29, 2010	122-123	148
Jake Owen	Mr. Buddy Jackson's house, Nashville	February 25, 2010	62-65	149
JD Souther	Grimey's Record Store, Nashville	August 25, 2009	50-51	150
Jim Lauderdale	Sheila B's house, Joelton, Tennessee	October 30, 2009	16-17	151
Jimmy Wayne	The Signature at MGM Grand, Las Vegas	April 4, 2009	114-115	152
Joe Nichols	The Signature at MGM Grand, Las Vegas	April 4, 2009	82-83	153
John Rich	Sommet Center, Nashville	November 11, 2009	38-39	154
Josh Turner	Ryman Auditorium, Nashville	March 15, 2010	86-89	155
Julianne Hough	The Signature at MGM Grand, Las Vegas	April 4, 2009	30-31	156
Kenny Chesney	Mr. Chesney's property, St. John, US Virgin Islands	December 7, 2004	12-13	157
Kenny Rogers	The Fox Theatre, Atlanta, Georgia	November 8, 2005	66-67	158
Lee Ann Womack	The Hermitage Hotel, Nashville	June 13, 2009	124-125	159
Little Big Town	The Hermitage Hotel, Nashville	June 12, 2009	92-95	160
Little Jimmy Dickens	Studio A, Grand Ole Opry House, Nashville	June 12, 2009	44-45	161
Martina McBride	Shot on location at Radio City Music Hall, New York, New York	July 15, 2009	36-37	162
Marty Stuart	Studio A, Grand Ole Opry House, Nashville	October 15, 2009	110-111	163
Mel Tillis	The Academy Theater, Lindsay, Ontario, Canada	October 17, 2009	84-85	164
Miranda Lambert	Old Tennessee State Prison, Nashville	September 14, 2009	14-15	165
Patty Loveless	Broadway Drive-in, Dickson, Tennessee	August 26, 2009	78-79	166
Randy Travis	Little River Casino Resort, Manistee, Michigan	December 11, 2009	104-105	167
Ray Benson	Bismeaux Studio, Austin, Texas	March 3, 2010	28-29	168
Reba McEntire	Sommet Center, Nashville	November 11, 2009	22-23	169
Rodney Atkins	Mr. Alan Jackson's cabin, Franklin	July 8, 2009	80-81	170
Rodney Crowell	A church in Woodstock, Vermont	November 28, 2009	128-129	171
Rosanne Cash	BMI, New York	December 7, 2009	46-47	172
Roy Clark	Riverside Resort, Laughlin, Nevada	November 13, 2009	100-101	173
Shelby Lynne	Mr. Brian Harrison's home studio, Nashville	August 19, 2009	116-117	174
Sugarland	The Four Seasons Hotel, Las Vegas	May 18, 2008	52-53	175-176
Taylor Swift	Ms. Swift's home, Hendersonville, Tennessee	July 20, 2009	72-73	177
The Oak Ridge Boys	Artistic Ironworks, Nashville	June 11, 2009	54-57	178-181
Trace Adkins	Studio Berry Hill, Nashville	January 21, 2010	34-35	182
Trisha Yearwood	The Ritz Carlton Residences at LA Live, Los Angeles, California	September 10, 2009	68-69	183
Vince Gill	The Stage in the Grand Ole Opry House, Nashville	August 20, 2009	112-113	184
Wynonna Judd	Citation Support, Nashville	June 22, 2008	58-59	185

THANKS, Y'ALL

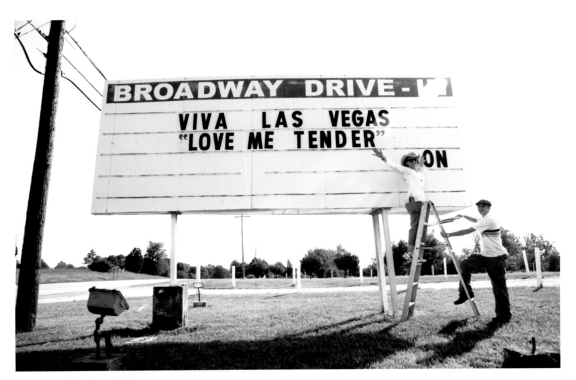

Photograph by David Johnson

I promised making this book would be easier than making the last one was. I was wrong. Nigel, thank you for your constant support and assurance and for being so darned optimistic.

And thank you to everyone else who made this book possible:

The lovely Emma and Jack, who are as lovely today as the day I met them.

Thank you millions and bazillions Geoff Katz, Jennifer Stanek, Hugo Reyes, Allison Krupke, Jeff Dymowski, Danny and Lisa Greer, Anita Katz, Casey Levine, and the team at CPI, who hear from me every single day, whether they want to or not.

Giovanni Russo, Koji Hokari, Marie Cortadellas, Florence Sicard, and the folks at No11: Without your fabulous design, the book would be a messy heap of papers and photos.

Jim Sherraden and Jennifer Bronstein at Hatch Show Print: Thanks for adding some Nashville spirit.

Taylor Steel, the amazing keeper of all order chez DuParry. Shhh, don't tell our secrets!

Karen Rinaldi—how am I so lucky to have met you?!—who understands my cuckoo-luckoo ideas and humors me. Again and again.

Shannon Welch, Yelena Gitlin Nesbit, and the peeps at Rodale . . . for helping me make this into a book.

Becca Parrish and the ladies of Becca PR, Helen Medvedovsky, Lauren Fonda, Tammy Walker: You are the nicest and definitely finest looking women in PR.

Drew Patrick: A better lawyer could not be had.

Lori Berger: You are a legend, and girl, you taught me a lot.

Farley Chase, literary agent extraordinaire: On to the next . . .

There are many more people in my life who are long suffering . . .

THANKS, Y'ALL

Alessandro, Louis, and Eva Russo

Alexandre Chemla

Alina Lundry

All of my fabu cousins in OZ

Altour International

Ami Vitale

Anne Madden

April Dace

Bekka and Ben Tiskcher

Beth and Curtis Groves

Bob and Vero Pittman

Bruce Perez

Carmen Mark Valvo

Carol Heron Gering

Charlie Feldman

Charlie Mars

Chris Dougherty

Christine Hahn

Christian Knaust

Christine Mulkhe

Christine Ramage

Cindy Sanz

Citation Support

Danny Greer

Donna Imbriani

Florence, Martine, and Yves Sicard

Frank Pulice

George Dunea

Helen Beadleston

Industria Superstudios

Jayne Young

Jenna Menard

Jenny Fine

Jennifer Crawford

Joanna McClure

Jo Horgan

John Barr

John Olson

Kate and Jack Steel

Ken Friedman

Kimberly Slayton

Kristin Powers

Larry Hackett

LeeAnn Jarvis

Maggie Murphy

Mario Batali

Martha Nelson

Mark Cornell

Mary Barr

Mary Dunea

Mary Louise Parker

Nancy Coles

Nikki Wang

Paul Katz

Paula Froelich

Peter Gargagliano

Sheila Bartlett

Skyler Spohn

Stacy Morrison

Sutton Crawford

Sydney and Ron Crawford

Uncle David

Will King

A special thank-you to the artists for trusting me and allowing me a glimpse into their world.

I also want to thank all of the people and places around them who made it all happen and helped me—and

didn't have me arrested for stalking.

Abe Baruck
The Academy Theater, Lindsay, Ontario
Alicia Lanier
Alicia Brown
Alison Auerbach
Amber Greene
Amber Williams
Amy Lewis
Angie Gore
The Basement
Betsy Baird
Betty Hofer
Bill Beeskow
Bill Gatzimos
Brandon Gill
Brian Chism
Brian Harrison
Broadway Drive-In
Carolyn Tate
Christos Gatzimos
Christian Bowen
Cindy Heath
Claudia Fowler
Chris Haley
Cliff Williamson
Clint Higham
Colleen Runne
Country Music Hall of Fame
Danny Kahn
Darrick Kinslow
Darlene Bieber
Darrell Beatty
David Johnson
David Whitehead
Debra Wingo Williams
Dixie Owen
Dottie Oelhafen
Donna Schacher
Doyle Davis
The Dudney Family
Earl Cox
Ebie McFarland
Eileen Duffin
Elizabeth Jordan
Elizabeth Travis
Emily Evans
Ensign Boyer
Enzo DeVincenzo
Erv Woolsey
Frank Rand
Gail Gellman and Hellen Rollens
Gennie L. Freeman
Gina Keltner
Grand Ole Opry
Gregg Hill

Mike Grimes
Hermitage Hotel
Holly Gleason
Holly Lowman
Jack Steel
Janelle Lopez
Janet Kurtz
Jared Paul
Jason Owens
Jason Henke
Jaycee + Reese
Jenn Pope
Jennifer Bohler
Jennifer Bretschneider
Jennifer Witherell
Jeremy Westby
Jeremy Rush
Jerri Cook
Jessie Schmidt
Joe the Horse!
Jim Mazza
John Dennis
John Daines
John McBride
Jon Mire
Joseph Cassell
Josh Nelson
Josh Walker
JW Williams
Karen Fleming
Kathy Best
Kathy DeMonaco
Kelly Green
Kelly Hobbs
Kirt Webster
Kristie Sheppard
Kristin Palmer
Lance Atkinson
Larry Jo Robertson
Laura McCorkindale
Lauren Simpson
Lee Willard
The Little River Casino Resort
Lori Phillips
Lorrie Turk
Lugo Munoz
Maria Verel
Marion Kraft
Maria-Elena Orbea
Marybeth Felts
Matt Dudney
Melanie Wetherbee
Michelle Schweitzer
Melissa Schleicher
Michael Robertson

Michelle Owens
Mike Grimes
Mike Holzmer
Mike Thomas
Mr. P
Nancy Scibilia
Narvel Blackstock
Natalie Burkholder
Natalie Kilgore
Nathan Lux
Navy ROTC at Vanderbilt University
Paula Erickson
Perri Crutcher
Pete Fisher
Radio City Music Hall and MSG Entertainment
Ragtop Picture Cars
Rebecca Stoehner
Regina Stuve
Rhonda Adams
Richard Claffery
Robert Allen
Robert Devine
Roberta Brown
Ross Smith
Roy Jerigan
Ryan Nelson
Ryman Auditorium
Sandy Brokaw
Sandy Judge
Sara Winne
Schatzi Hageman
Scott and Sandi Borchetta
Sherry's Wheels
Sergeant Hampton
Staff Sergeant Brad Kinsey
Steve Geary
Studio: Audio 51
Technical Sergeant Steven D. White,
U. S. Air Force
Tennessee National Guard
Tennessee Department of Correction
Teresa Blackburn
Tiffany Shipp
Tiffany Bearden
Tina Wright
Tommy Garris
Tony Brown
Tree Paine
Trish Townsend
Tyler Bryan
Vanessa Scali
Wes Vause
William Bullens

Rodale books may be purchased for business or promotional use or for special sales. For information, please write to:
Special Markets Department, Rodale Inc., 733 Third Avenue, New York, NY 10017.

Printed in China
Rodale Inc. makes every effort to use acid-free ∞, recycled paper ♻.

Book design by Giovanni Carrieri Russo / No11, Inc
Photographs by Melanie Dunea

Library of Congress Cataloging-in-Publication Data

Dunea, Melanie.
 My country : 50 musicians on God, America & the songs they love / Melanie Dunea.
 p. cm.
 ISBN-13 978–1–60529–651–7 hardcover
 ISBN-10 1–60529–651–1 hardcover
 1. Country musicians—United States—Pictorial works. 2. Country musicians—United States—Interviews. I. Title.
ML87.D73 2010
781.642092'273—dc22 2010018318

Distributed to the trade by Macmillan

2 4 6 8 10 9 7 5 3 1 hardcover

RODALE